Narrative Picture Scrolls

EDITORIAL SUPERVISION
FOR THE SERIES

Tokyo National Museum
Kyoto National Museum
Nara National Museum
with the cooperation of the
Agency for Cultural Affairs
of the Japanese Government

FOR THE ENGLISH VERSIONS
Supervising Editor
John M. Rosenfield
Department of Fine Arts, Harvard University
General Editor
Louise Allison Cort
Fogg Art Museum, Harvard University

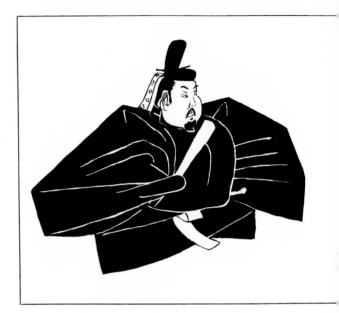

NARRATIVE PICTURE SCROLLS

by Hideo Okudaira

translation adapted with an introduction by Elizabeth ten Grotenhuis

New York · WEATHERHILL/SHIBUNDO · *Tokyo*

This book appeared originally in Japanese under the title Emakimono (Narrative Picture Scrolls), as Volume 2 in the series Nihon no Bijutsu (Arts of Japan), published by Shibundō, Tokyo, 1966.

The English text is based directly on the Japanese original, though some small adaptations have been made in the interest of greater clarity for the Western reader. Modern Japanese names are given in Western style (surname last), while premodern names follow the Japanese style (surname first).

For a list of volumes in the series, see the end of the book.

First edition, 1973

Published jointly by John Weatherhill, Inc., 149 Madison Avenue, New York, N.Y. 10016, with editorial offices at 7–6–13 Roppongi, Minato-ku, Tokyo; and Shibundō, 27 Haraikata-machi, Shinjuku-ku, Tokyo. Copyright © 1966, 1973 by Shibundō; all rights reserved. Printed in Japan.

Library of Congress Cataloging in Publication Data: Grotenhuis, Elizabeth ten./Narrative picture scrolls./(Arts of Japan, 5)/Adapted from Emakimono./Bibliography: p. /1. Scrolls, Japanese./2. Painting, Japanese./3. Japan—Social life and customs —Pictorial works. I. Okudaira, Hideo, 1905– Emakimono. II. Title./ND1053.G76 1974/759.952/73–9619/ISBN 0–8348–2710–7 ISBN 0–8348–2711–5 (pbk.)

Contents

Adapter's Preface

THANKS TO THE scrupulous scholarship of Mrs. Yasuko Horioka, who did the original translation of the Japanese text, it has been possible to develop a book in English that retains the inherent interest and charm of Mr. Okudaira's work. Because the book was intended for Japanese readers and assumed a great deal of prior knowledge about Japan, I have edited, rewritten, and reorganized considerably. Much new explanatory information has been incorporated: within the chapter entitled "Historical Development," The Heritage of China, The Buddhist Narrative Tradition, and The Legacy of the Emaki and Yamato-e are entirely new sections. In adding this information, my aim has been to complement Mr. Okudaira's work and to enlarge on some of the themes he suggests. The chapter entitled "The Emaki as an Art Form" was culled from various shorter chapters in the original Japanese work, for it seemed wisest to reorganize and arrange in a more logical manner the array of material presumably unfamiliar to the general Western reader.

The book has a useful format: Not only are the history and artistic characteristics of illustrated handscrolls discussed, but there is also an extensive section entitled "Selected Individual Emaki" that offers synopses of the plots of forty-four major *emaki* as well as other pertinent information about them. It is suggested that the reader use these notes as he encounters the various *emaki* mentioned only briefly in the text as examples or illustrations.

The great appeal of these narrative picture scrolls lies not only in the skill and imagination with which the illustrations were composed and painted, but also in the panorama of Japanese life and culture they present. It is this combination that Mr. Okudaira has endeavored to explore and develop so as to deepen our understanding and appreciation of this unique art form and that all of us who have worked on the English version of the book have sought to preserve.

E. ten G.

Introduction: The Emaki and Yamato-e

THE EMAKI or "picture scroll" is a unique and dramatic form of art. Holding an *emaki* scroll in his hands, the viewer gradually unrolls a pageant of interwoven scenes and text as he becomes immersed in the unfolding story. This intimate handscroll format, so well suited to narrative, captured the imaginations of Japanese artists and patrons for centuries. Hundreds of *emaki,* dating mainly from between the twelfth and sixteenth centuries, exist today to bear witness to the importance of this art form in medieval Japan. The form lent itself to every sort of story, from solemn religious accounts to romantic intrigues to rollicking adventures and homely folk tales. It was the major vehicle for the rich and lyrical style of painting known as *yamato-e.*

The Japanese began to make *emaki* under Chinese influence, but the picture scroll in Japan developed into a more dynamic art form than its Chinese counterpart. Although Japanese artists were not indifferent to the portrayal of landscape and nature that was so popular in China, the subject of *emaki* art was generally man; its themes, the way man lives and interacts with his fellow man. The greater part of *emaki* art deals with the tragic and humorous aspects of the human condition and depicts stories and narratives in which the natural and the supernatural are intermingled. Scroll paintings may be roughly divided into two types according to content—religious and secular—but many contain elements of both types. Most *emaki* in the religious category were inspired by Buddhist themes, although some are related to Shintoism. Such scrolls, many of which were made during the social upheavals of the late Heian and early Kamakura periods (897–1249), often reflect the religious pessimism of the day; they were in part produced to express and to heighten the viewer's longing for escape into paradise by exposing the horrors of the reincarnation cycle (the *Gaki Zōshi* [Scroll of Hungry Ghosts], the *Jigoku Zōshi* [Scroll of Hell], and the *Yamai no Sōshi* [Scroll of Diseases and Deformities]). There were also religious scroll paintings depicting the legendary origins of shrines and temples and the virtues of their principal deities; for example, the *Shigi-san Engi* (Legends of Shigi-san Temple), as well as pictorial biographies of exemplary priests or founders of sects, such as the *Hōnen Shōnin Eden* (Biography of the Monk Hōnen).

Scrolls in the secular category were created to serve aesthetic and narrative purposes and were often painted to illustrate literary works, narrative accounts, folk tales, war stories, *waka* poetry, and documentary records. Most of the literary *emaki* are based on the romantic literature of the Heian (794–1185) and Kamakura (1185–

1336) periods and portray the elegant lives of the court aristocracy; one example is the well-known *Genji Monogatari Emaki* (The Tale of Genji). The narrative accounts, mostly executed during the Kamakura period, deal with supernatural occurrences, bizarre tales, adventure stories, or humorous events. An outstanding example is the *Ban Dainagon Ekotoba* (Story of the Courtier Ban Dainagon). Folk-tale scroll paintings *(otogi zōshi emaki),* based on stories written mostly during the Muromachi period (1336–1568), were also a popular type of *emaki.* The *Fukutomi Zōshi* (Story of Fukutomi) and the *Tsuchigumo Zōshi* (Story of Monstrous Spiders, Plate 39) are examples. Although literary sources indicate that a large number of scrolls dealing with military history was produced, only a few, such as the *Heiji Monogatari Emaki* (The Tale of the Heiji Rebellion) and the *Mōko Shūrai Ekotoba* (The Mongol Invasion), survive; most others, such as the *Hōgen E* (The Hōgen Civil War) and the *Heike Yashima Kassen E* (The Heike Battle at Yashima) have been lost. Poetry *(waka)* scrolls do not display the narrative quality of other *emaki,* but rather illustrate the popular medieval Japanese pastime of composing thirty-one-syllable poems. Each poem in such a scroll is illustrated by a scene, usually a landscape related to the poem, or by a portrait of the poet. Documentary *emaki* record historical events, festivals, and ceremonies— one example is the *Nenjū Gyōji Emaki* (Annual Rites and Ceremonies).

Although illustrated handscrolls are now known as *emaki* (or *emakimono),* in earlier centuries they were not distinguished from other forms of painting. Literary sources indicate that the *Genji Monogatari Emaki* was called simply *Genji E,* or "Genji Painting," and that the names of other scroll paintings merely added the suffix *e* to indicate "picture, illustration." It was not until the late Edo period (1603–1868), when this form of art had experienced a decline in real vitality and originality, that the term *emaki* came into existence. It may have been devised to distinguish the genre from the hanging scrolls *(kakemono)* that were popular throughout the Edo period, for *emaki* and *kakemono* differ considerably in form and content. Today a variety of descriptive terms are employed to distinguish among the types of *emaki: monogatari emaki* illustrate a narrative *(monogatari)* such as a novel or story or historical account in literary form; *nikki emaki* illustrate a diary *(nikki).* In the *ekotoba* (literally, "picture and word"), text and illustrations alternate. A picture album or a series of sketches, usually connected by a common theme, is known as a *sōshi* (often *zōshi* in compounds). Among scrolls with religious themes, *engi* (a term that literally means "dependent origination" and refers to the Buddhist doctrine of cause and effect) deal with the legendary origins of shrines or temples. *Eden* are the pictorial biographies of important historical personages, usually monks and priests. There are also the *kasen emaki,* poetry scrolls with portraits of the poets, and *uta-awase emaki,* handscrolls with scenes of poetry contests.

The *emaki* is perhaps the most representative expression of *yamato-e,* a rather vague term referring to paintings depicting Japanese subjects and scenes and inspired by Japanese sentiments. Yamato, the area south of the old capital of Nara, is considered the heart of the Japanese nation. *Yamato-e* or "Yamato painting" therefore means Japanese-style painting or "painting in the Japanese manner" and stands in contradistinction to *kara-e,* "Chinese-style painting." *Kara-e* came into Japan as part of the wholesale importation of Chinese culture that began in the mid-sixth century and was formalized after Prince Shōtoku established diplomatic relations with Sui China in 607. Continental influence, both that of Chinese Buddhist culture as well as that of the secular arts, was strong until the ninth century, and throughout this period the model for painting was *kara-e.* The Chinese persecution of Buddhism in the mid-ninth century, however, served to confirm Japanese fears that the T'ang dynasty (618–907), once so admired and emulated, was crumbling. As they have often done after a period of considerable borrowing from abroad, the Japanese turned inward and discontinued diplomatic relations with China in 894. They soon found expression for their sentiments and feelings in a literature and art in which vestiges of T'ang influence were incorporated into an increasingly native style. Japanese authors had long written in Chinese; now they began to explore their own language, using the newly created phonetic syllabary *(kana).* In the field of painting, *yamato-e* was free to develop.

While there are no surviving examples, numerous references to painting in the Japanese style *(yamato-e)* can be found in tenth- and eleventh-century Heian literature. We know that *kana* poems from Heian-period anthol-

ogies were often inscribed and illustrated on screens and sliding doors; these were presumably the earliest expressions of *yamato-e*. Many of the poems dwell on the beauties of Yamato and on the Japanese love for their homeland and were almost certainly complemented by paintings of Japan. Other subjects of these illustrated poems include the occupations of the twelve months of the year *(tsukinami-e)*, views of famous scenic sites *(meisho-e)*, and scenes of the four seasons *(shiki-e)*. But it was for the *monogatari-e* or "story paintings" which developed in the Heian period that the *emaki* format proved eminently suitable.

By the twelfth century *yamato-e* had reached its maturity. One of the earliest extant scroll paintings, *The Tale of Genji* (c. 1120–40), is a superb example of the courtly or *onna-e* ("women's painting") style of *yamato-e;* this formal, decorative style is characterized by a highly stylized, nondescriptive treatment of faces; the convention of showing interior scenes by removing the roof; a highly sophisticated sense of color harmony; exploration of the potentials of pure abstraction in form; and the use of parallel diagonal lines and a high-level viewpoint in composition. Yet such *emaki* are not limited to works in color; some are drawn in black ink alone. And in contrast to the quiet, relatively static scenes of court life, there are *emaki* whose quick, fluid brushstrokes and integrated narrative composition emphasize lively action and vivid characterization. Buddhism, and to a lesser degree Shintoism, often provided the inspiration for these *otoko-e* ("men's painting") *emaki,* which can take the form of dramatic chronicles of the founding of a Buddhist temple or Shintō shrine or of stories with a religious moral. Whereas courtly *emaki* deal exclusively with the lives and concerns of the nobility and seldom show anyone of low rank, the noncourtly *otoko-e emaki* often show an interest in the boisterous life of the lower classes, who are depicted with a humor that sometimes borders on caricature.

The term *yamato-e* connotes not only a departure from the subject matter of *kara-e* but also a different way of interpreting the world. The Japanese seem to have a fundamentally more emotional, less philosophical and intellectual approach toward life and art than do the Chinese. The Japanese tend to view painting more personally and more as decoration; hence their fascination with color and with abstract form. This is not true for all periods and styles in Japanese art history, but it certainly characterizes *yamato-e,* and within *yamato-e,* the *emaki* tradition.

Narrative Picture Scrolls

There were handscrolls based on literary works such as the ninth-century *Taketori Monogatari* (The Tale of the Bamboo Cutter), the oldest work of fiction in Japanese; the *Utsubo Monogatari* (The Tale of Utsubo); and the *Ise Monogatari* (The Tales of Ise); there were also scroll paintings illustrating the new manners and customs of the period. Although most *emaki* deal with Japanese themes and scenes, some depict Chinese historical events such as the story of Wang Chao-chün, a beautiful court lady of the Han period who was forced to marry the leader of the Huns, the barbarian enemies of the Chinese in the north.

The author of *The Tale of Genji* describes the *emaki* of those days as "dazzling to the eyes." This resplendent quality was no doubt in part a result of the elegantly decorated paper, braided silk cords, and costly covers that were used—all elements of *emaki* carefully described in the novel. She writes of the scroll paintings based on literary works that "they are superior to other scrolls because the pictures are exquisite and charming"; she remarks through one of her characters that "the pictures that illustrate literary works deserve attention." These statements very likely represent common opinion of the period, and we have every reason to assume that most of the *emaki* produced at this time were illustrations of literary works.

One distinctive spirit underlying much of this literature and, by extension, the *emaki* that illustrated it is termed *mono no aware*. *Mono no aware* is the association of beauty and sorrow, the recognition that what is beautiful is also pathetic because it is inevitably transitory and doomed to disappear. A sense of gentle

やとひはみつゝ
やふみ□てむ
とゝみ□
□□
うよ
ひのしよ
まりかろに
たつゝをそを
はけ

ねあ
人のあめあ
たけおみ
けろうのり
てみ
はし

◁ *8.* Genji Monogatari Emaki. *This scroll painting includes some of the most exquisite sections of calligraphy found in* emaki. *Paper decorated with gold and silver dust as well as strips of gold and silver was used. Textual portions written in the native Japanese syllabary* (kana) *in a loose and flowing style always precede the pictorial illustrations they describe, and often narrate parts of the story that are not illustrated. To the Japanese sense of aesthetics, calligraphy was not just a means of conveying a message, but was an art form worthy of the highest respect and requiring the most sophisticated training. Paper on which calligraphy was executed was carefully chosen, and at times, as is evident here, the paper itself was richly decorated. Heian period, 12th century. Gotō Art Museum, Tokyo.*

melancholy pervades most of the highly aesthetic and refined activities of the court nobles. Prince Genji cannot admire spring blossoms without lamenting the fact that soon they will fade and that death, for all of us, comes ever closer. He constantly talks of wanting to retire from the world and become a Buddhist monk (a conventional sentiment of the time).

This self-conscious and somewhat indulgent melancholy was not merely the expression of a luxurious and indolent way of life that occasionally became wearisome; there was also a growing belief in eleventh-century Japan that the period of Mappō, "the end of the Buddhist Law," was imminent. Events of the twelfth century seemed to bear out this dire prediction: there were provincial rebellions, droughts, famines, epidemics, fires, and a seemingly sudden increase

in robbery, murder, and suicide. The established Buddhist sects of Shingon and Tendai, with their complicated speculative doctrines and mystic ritualism, began to be superseded by a new popular cult centered on the transhistorical Buddha Amida, who offered release from pain through rebirth in his Western Paradise to all those who merely invoked his name.

Painting of the tenth century was, as we have seen, closely associated with contemporary literature; each complemented the other, and the viewer appreciated the atmosphere created by the blending of the two. In *emaki,* artists preferred the monoscenic form of composition, in which sections of text alternate with illustrations. The tendency to associate picture and text can also be seen on folding screens and sliding doors. A *waka* poem related to a painting was often written

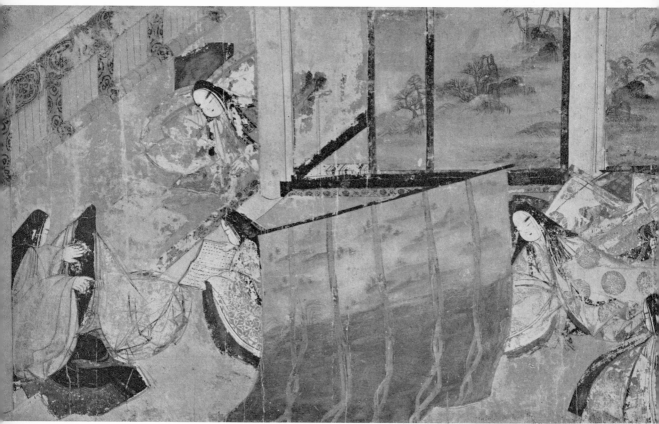

9. Genji Monogatari Emaki. *Heian period, 12th century. Tokugawa Art Museum, Nagoya.*

on a square piece of cardboard called a *shikishi* and pasted on a screen painting or sliding door. Sometimes the writing was even more closely tied in with the painting so that a synthesis of the two was created: In this case, the poem was written in such a way that the cursive *kana* characters fit into the picture and formed an image, such as the outline of a rock or plant. This technique is called *ashide-e,* which means literally "reed-hand painting." Devices of this sort no doubt also influenced *emaki* art of the period.

• THE DEVELOPING STAGE (the twelfth century). The aristocrats of Kyoto derived their economic wealth from large estates managed by a provincial gentry class of stewards and other officials that soon became a force to be reckoned with. During the eleventh cen-

tury, several emperors, in particular Gosanjō (1069–72) and his son Shirakawa (1072–86), attempted to limit the power of the Fujiwara clan. They were aided in this effort by various noble families that had been sent to the provinces to defend the frontiers against unconquered tribes.

The imperial house soon became dependent on these provincial clans, the most powerful of whom were the Taira (otherwise known as the Heike) and the Minamoto (or Genji). During the twelfth century, these two great clans struggled for supremacy. In 1159 the Taira were victorious under their leader Kiyomori, but after Kiyomori's death, two brothers of the house of Minamoto, Yoritomo and Yoshitsune, raised forces once again against the Taira. In the sea battle of Dannoura in 1185, the Minamoto utterly defeated the

10. Genji Monogatari Emaki. *Heian period, 12th century. Tokugawa Art Museum, Nagoya.*

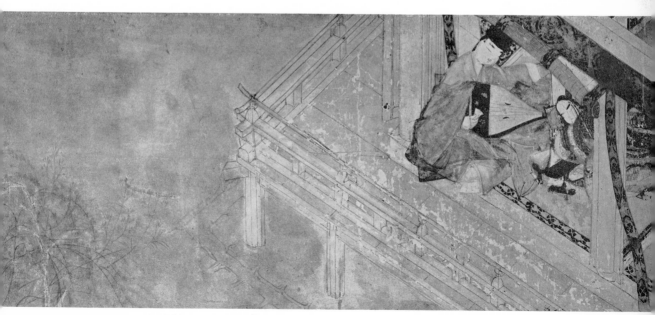

11. Genji Monogatari Emaki. *Heian period, 12th century. Tokugawa Art Museum, Nagoya.*

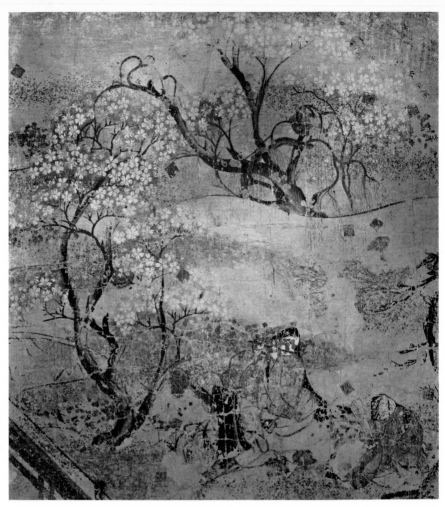

12. Nezame Monogatari Emaki. *Heian period, 12th century. Yamato Bunkakan, Nara.*

Taira. Yoritomo proclaimed himself the *shōgun* (military dictator) of the country and moved the seat of government to Kamakura, a small village in eastern Japan that gave its name to the ensuing historical period. The emperors continued to live in Kyoto and remained the titular rulers of the country, but they were never able to wrest control of the government from the military leaders who stood at the apex of the emerging feudal social structure.

Emaki of the time reflect the changes that were taking place in the social and political structure of the country. Romantic scroll paintings based on literary works were gradually replaced by more dynamic narrative accounts that stressed the development of plot. A popular element was added to the repertoire of *emaki* as interest in the lives of the common people

increased: we are given glimpses into the lives of ordinary folk as well as those of aristocrats. And in addition to the traditional technique of building up images with heavy, opaque pigments that were then outlined in black, free-style drawing came to be used to sketch lively scenes in which movement was paramount.

Despite changes and new developments, a sense of nostalgia for the past is also a hallmark of this time. The *Eiga Monogatari* (Tale of Splendor), a forty-volume romanticized history of the imperial court written in the late eleventh century, and stories inspired by works like *The Tale of Genji* glorified an earlier time. Tradition also played a large role in art; artistic techniques were carefully handed down and preserved. Another, almost contradictory, aspect of the period was the per-

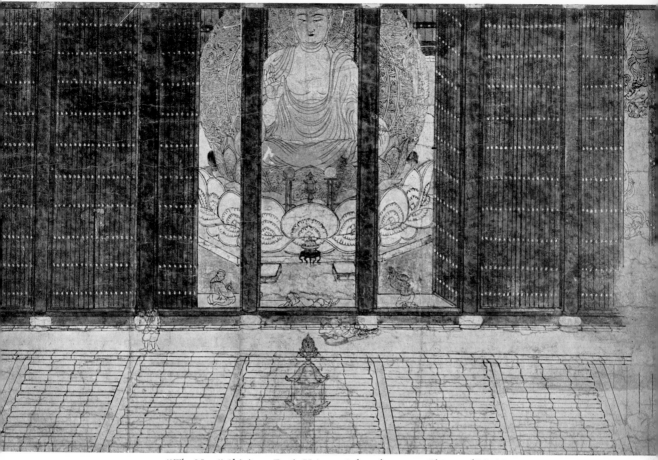

13. *"The Nun,"* Shigi-san Engi. *Heian period, 12th century. Chōgosonshi-ji, Nara.*

meation into aristocratic circles of a more popular culture. The nobles seemed to crave anything new. Popular entertainment from the lower classes, such as *sarugaku* and *dengaku,* humorous and often vulgar dance and song arrangements accompanied by drums and flutes, which were early forms of Nō drama, were performed before aristocratic gatherings. Stories of warriors and commoners, who had seldom appeared in literature before, as well as more frankly ribald accounts gained an increasingly wider audience.

Among these new works of literature was the *Konjaku Monogatari,* a thirty-one-volume collection of narratives in which people from all walks of life were treated as heroes. The fact that the aristocracy began to look to the lives of the common people for inspiration and entertainment indicates the decline of a

genuine patrician flavor in the culture at large. These two trends—namely, a respect for the past and an attention toward new concerns—helped create a variety of new and important *emaki.* Four masterpieces —the *Genji Monogatari Emaki* (The Tale of Genji), the *Shigi-san Engi* (Legends of Shigi-san Temple), the *Ban Dainagon Ekotoba* (Story of the Courtier Ban Dainagon), and the *Chōjū Jimbutsu Giga* (Scroll of Frolicking Animals and People)—all belong to this period.

In the *Genji emaki,* we see the style of the early period faithfully transmitted, though rendered in a highly refined manner. By contrast, the *Shigi-san* and *Ban Dainagon emaki* herald a new era and new styles. Unlike the *Genji emaki,* which depicts events from classical literature of court origin, the *Shigi-san Engi* illustrates the legendary miracles performed by a Bud-

14. "The Flying Granary," Shigi-san Engi.
Heian period, 12th century. Chōgosonshi-ji, Nara.

dhist monk named Myōren. The scroll painting itself probably dates from the middle decades of the twelfth century. It stands as a counterpart to the *Genji emaki* not only in content, but also in form. The *Genji* handscrolls are characterized by alternating textual and pictorial portions, whereas the *Shigi-san Engi* contains only four textual sections in its three scrolls; the narratives are depicted in the form of a continuous composition in which one scene moves effortlessly into the next. Unlike the *Genji emaki,* which is painted with the heavy, opaque pigments of the *tsukuri-e* technique, the *Shigi-san Engi,* which is faintly colored, stresses line drawing to depict the swiftly moving events. Its setting is wider in scope as well: there are landscapes and outdoor scenes, and the interior views to which scrolls such as the *Genji emaki* are limited are not seen at all.

The *Ban Dainagon Ekotoba,* which dates from the second half of the twelfth century, employs the styles of both the *Genji* and *Shigi-san* scrolls and emphasizes color and line drawing. In terms of content and form, however, the *Ban Dainagon emaki* is much closer to the *Shigi-san Engi:* it is a continuous composition over twenty feet long that devotes itself to the unfolding of a dramatic story. Although the *tsukuri-e* technique is used, the artist has also employed free-style drawing to add movement and vitality to the hundreds of figures he portrays. The *Ban Dainagon Ekotoba* goes a step further than the *Shigi-san Engi* in its treatment of individual figures and faces and in its sophisticated handling of crowd scenes.

The first scroll of the *Chōjū Jimbutsu Giga,* which probably dates from the second quarter of the twelfth century, differs from the other three scroll

paintings in that it is executed in ink alone. This *emaki* depicts all sorts of playful animals who seem to be parodying human beings. A religious ceremony at the end of the first scroll (Plate 25) in which a monkey-priest prays before a statue of the Buddha in the form of a frog, for example, is clearly an essay in religious satire. The *Chōjū emaki* is no doubt derived in style and technique from Buddhist iconographic drawings executed in monochrome ink. Kōzan-ji, where it is preserved, was a center for this kind of drawing, and the scrolls may have been produced as a diversion by the monk-painters who worked in the temple atelier.

• THE MATURE STAGE (thirteenth to mid-fourteenth centuries). After Minamoto Yoritomo's death, power passed into the hands of the Hōjō clan, who were related to the family of Yoritomo's wife. The Hōjō

regency, established in 1205, endured until 1333. One of its most significant accomplishments was successfully fending off the attacks of the Mongols in 1274 and 1281. The militaristic spirit of the new ruling class was reflected in contemporary culture. Despite the fact that political and military power was centered in Kamakura, the cultural focus of the country was still Kyoto, where the traditional arts continued, now vitalized by the new more realistic and vigorous currents.

One of the most important cultural developments of the period was the rise of popular Buddhist salvation sects in response to social unrest and to the deterioration of the previously powerful religious sects. Hōnen Shōnin (1133–1212) founded the Jōdo or Pure Land sect; his disciple Shinran Shōnin (1173–1262) carried his master's reforms still further and established the Jōdo Shinshū or True Pure Land sect. Ippen Shō-

15. *"The Nun,"* Shigi-san Engi. *Heian period, 12th century. Chōgosonshi-ji, Nara.*

nin (1239–89), a peripatetic singing and dancing monk, founded yet another Pure Land sect, the Jishū or Timely sect. Still another popular sect was established by Nichiren (1222–82), a fanatic and nationalistic devotee of the Lotus Sutra *(Hoke-kyō)*. The Zen sect was also formally introduced from China and established in Japan in the beginning of the thirteenth century, but Zen, with its emphasis on meditation and self-discipline, appealed more to the warriors than to the mass of common people. These new sects were important for yet other reasons: they motivated the older sects, such as those of Tendai and Shingon, to reform, and in their doctrines and guiding personalities they provided a new source of inspiration for *emaki* art.

During the Kamakura period (1185–1336), *emaki*

art, reflecting the contemporary cultural and social changes, increased in complexity both in content and in style. A focus on explanatory narration superseded the earlier emphasis on decoration, and realistic concerns supplanted the older abstract designs and romantic tone. Monks as well as samurai warriors and the hereditary nobility became patrons of *emaki*. During the late Heian period most *emaki* had been produced by professional court painters supervised by the court bureau of painting (Kyūtei Edokoro), but during the Kamakura and ensuing Muromachi periods, *emaki* production took place more and more in temple and shrine workshops *(jiin-edokoro)*, at the hands of professional monk-painters. The production of *emaki* steadily increased, and the thirteenth century is considered the golden age of this art form.

16. "The Flying Granary," Shigi-san Engi. Scroll I. This handscroll is popular not only for its entertaining content, but also for its lively artistic execution. The first scroll, a section of which is shown here, concerns a magic golden begging bowl that belongs to the monk Myōren. Myōren, rather than descending from his home on Mount Shigi, sent his bowl directly to the granary of a rich man. One day, however, the servants neglected the bowl and left it unfilled in the granary, whereupon it slipped out under the building and flew off, carrying the whole building and all the stored-up rice bales with it. In this scene the building flies by, supported by the bowl, to the astonishment of passers-by. Heian period, 12th century. Chōgosonshi-ji, Nara.

A wide variety of secular *emaki* included illustrated literary works, *waka* poems, narrative accounts, war chronicles, and documentaries. *Emaki* based on literary works retained the aestheticism associated with the court and court society. Many were created out of a sense of nostalgia—to commemorate the glorious court life of an earlier age and to pay homage to classical literature. Extant *emaki* of this group include the *Murasaki Shikibu Nikki Emaki* (Diary of Lady Murasaki), the *Ise Monogatari Emaki* (Tales of Ise, Plate 86), the *Hazuki Monogatari Emaki* (Tale of Hazuki, Plate 85), the *Komakurabe Gyōkō Emaki* (An Imperial Visit to the Horse Race), the *Ono no Yukimi Gokō Emaki* (The Imperial Visit to Ono for Snow Viewing, Plate 72), the *Toyo no Akari Ezōshi* (Scroll of Toyo no Akari, Plates 70 and 71), the *Makura no Sōshi Emaki*

(The Pillow Book), and the *Nayotake Monogatari Emaki* (Tale of a Young Bamboo).

The *emaki* illustrating *waka* poems, poets, and poetry meetings were also of court origin and inspiration, and reflected the immense popularity of *waka* poetry at the time. Among these works were the *Sanjūrokkasen Emaki* (The Thirty-six Poetic Geniuses), the *Ise Shin Meisho Uta-awase Emaki* (Poetry Contest on Newly Selected Scenic Spots in Ise), and *Tōhoku-in Shokunin Uta-awase Emaki* (Tōhoku-in Poetry Contest Among Members of Various Professions).

Literary sources tell us that a large number of *emaki* depicting war chronicles was created at this time, although most of them have since been lost. They reflected the developing samurai ethic and illustrated popular and often gory war accounts, for the civil

17. *"The Nun,"* Shigi-san Engi. *Heian period, 12th century. Chōgosonshi-ji, Nara.*

wars that had racked the country at the end of the Heian period provided a fertile source of inspiration for both literature and art. *Emaki* of this type that have come down to us include the *Heiji Monogatari Emaki* (The Tale of the Heiji Rebellion), the *Gosannen Kassen Ekotoba* (The Gosannen Battle, Plate 81), and the *Mōko Shūrai Ekotoba* (The Mongol Invasion).

Emaki of a documentary nature dealing with either historical events or portraits of people of historical significance were created under the influence of the realistic trend in portraiture *(nise-e)*. Existing *emaki* of this sort include the *Zuijin Teiki Emaki* (The Imperial Guard Cavalry), the *Kuge Retsuei Zukan* (Scroll of Portraits of Courtiers, Plate 48), and the *Tennō Sekkan Daijin Ei* (Portraits of Emperors, Regents, and Ministers, Plate 32).

Religious scroll paintings of the Kamakura period surpass in excellence even the finest secular *emaki*. With the exception of the eighth-century *E Inga-kyō* and the *Shigi-san Engi* of the late Heian period, religious *emaki* did not appear as a distinct subdivision of *emaki* art until this period. One impetus for their development was the emergence of new sects whose followers felt the need to record and illustrate the lives of the founders and to propagate the virtues of the new doctrines.

Both the religious and secular *emaki* of this period added a wide variety of characters to their repertoire. In addition to noblemen, people from all walks of life—including priests, samurai, farmers, fishermen, merchants, entertainers, and beggars—came to be depicted with humor and pathos. People from China,

18. *"The Miraculous Cure of the Engi Era,"* Shigi-san Engi. *Heian period, 12th century. Chōgosonshi-ji, Nara.*

Korea, and Central Asia were portrayed in their native costumes. And cities, mountain villages, and the countryside, used as background settings for *emaki*, added much local color. Several *emaki* that exemplify the new interest in both narrative subject matter and the lives of commoners are the *Yamai no Sōshi* (Scroll of Diseases and Deformities), the *Kibi Daijin Nittō Ekotoba* (Minister Kibi's Visit to China), the *Eshi no Sōshi* (Story of a Painter), and the *Haseo-kyō Zōshi* (Tale of Lord Haseo).

• THE LATE STAGE (early fourteenth to late sixteenth centuries). In 1333, Emperor Godaigo, with the help of various nobles, overthrew the Hōjō family. One of his supporters, however, Ashikaga Takauji, turned against the emperor in 1335, seized Kyoto, installed another imperial prince as emperor, and made himself shogun. Godaigo fled south and established a court in the mountainous Yoshino district. The period of dynamic schism, called the Age of the Southern and Northern Courts, lasted until 1392, when the grandson of Takauji, Ashikaga Yoshimitsu, forced the southern emperor of the time to abdicate.

The Ashikaga family, whose period of rule (1336–1568) is often called Muromachi after the part of Kyoto in which they lived, moved the government there from Kamakura. By the fifteenth and sixteenth centuries, however, internecine warfare made it difficult for the Ashikaga to maintain control. The Onin War, which raged for ten years in the fifteenth century, resulted in the destruction of much of Kyoto. The next century, until the last Ashikaga shogun was deposed by

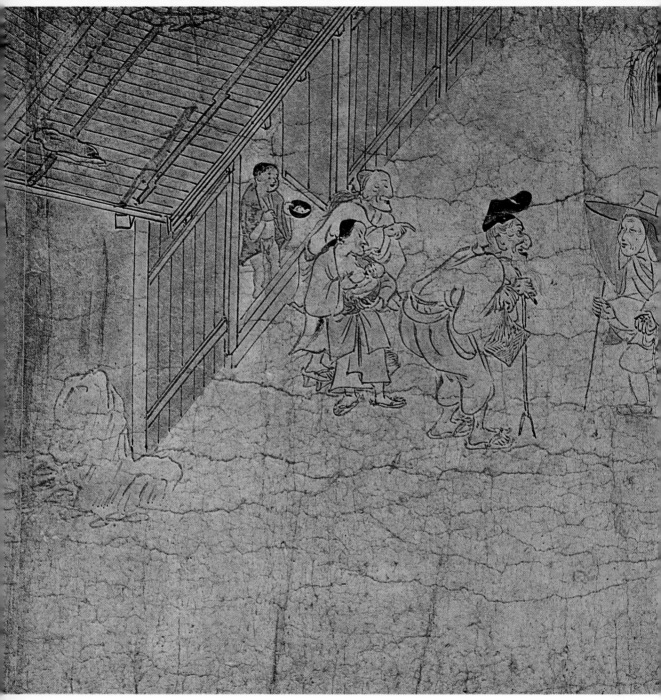

19. "*The Nun*," Shigi-san Engi. *Scroll III. The monk Myōren's sister, a nun, sets out in search of her younger brother, who had left home over twenty years before. In this scene we see her on her way to Nara, wearing a broad straw hat and simple nun's garb. She stops an aged passer-by to tell him her story and ask if he knows the whereabouts of her brother, as those nearby listen on with interest. The*

scene is unencumbered with detail, and it is just this simplicity, marked by the use of quick, thin lines, that makes this handscroll so appealing. Since the individuals portrayed are commoners and not aristocrats, the artist was free to depict various facial expressions and gestures. Heian period, 12th century. Chōgosonshi-ji, Nara.

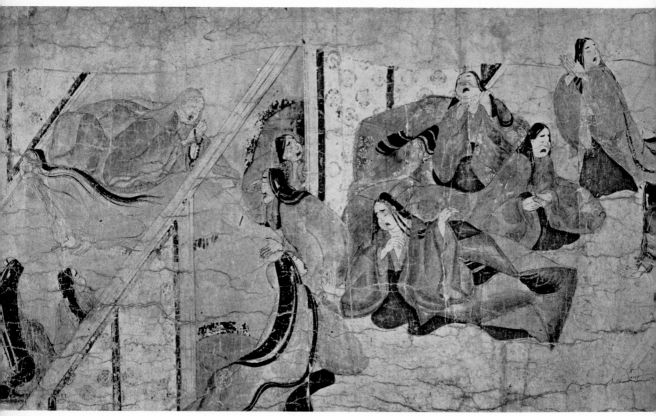

20. Ban Dainagon Ekotoba. *Heian period, 12th century. Sakai Collection, Tokyo.*

21. Ban Dainagon Ekotoba. *Heian period, 12th century. Sakai Collection, Tokyo.* ▷

Oda Nobunaga in 1573, is called Sengoku Jidai—Age of the Warring Provinces.

The *Kasuga Gongen Reigen Ki* (The Kasuga Gongen Miracles) is considered representative of *emaki* created during the transitional stage between late Kamakura and early Muromachi times. After the production of this work, however, *emaki* art succumbed to the trap of mannerism and lost a great deal of its charm and vitality. The deterioration, which went on as *yamato-e* declined in popularity, resulted in large part from the introduction of Chinese monochrome ink landscape paintings of the Sung and Yüan dynasties. This Chinese style of ink painting found favor among the new warrior-aristocrats in Kyoto who had become the arbiters of taste.

Emaki illustrating classical literature, *waka* poems, and poetry contests were gradually replaced by scroll paintings depicting *otogi zōshi* (folk tales). *Otogi zōshi*, written mainly during the Muromachi period, concerned common people, not the nobility; their themes range from various aspects of love to the supernatural and mysterious. The tales are recreational and illuminative, and often ethical and religious as well. Most emphasize plot, and some are extremely humorous. Many *emaki* illustrating *otogi zōshi* must have been made, because a great number of scrolls survive. Although all are anonymous, it seems likely that they were produced not only by artists of the orthodox schools of painting but also by *machi-eshi* (town painters), free-lance popular artists who were often trained

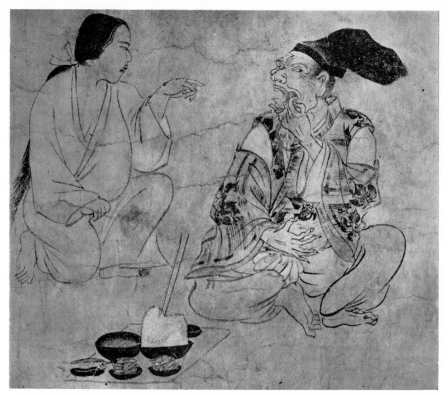

26. Yamai no Sōshi. *Kamakura period, 12th century. Sekido Collection, Aichi Prefecture.*

Other inheritors of the *yamato-e* tradition were Sō-tatsu (active c. 1630) and Ogata Kōrin (1658–1716). Influenced by the artistic and literary renaissance of Japanese aristocratic taste, which was largely directed by Hon'ami Kōetsu (1558–1637), Sōtatsu, who was not only an artist in his own right but also a restorer of ancient scrolls, borrowed themes from such hand-scrolls as the *Genji Monogatari Emaki* and the *Saigyō Monogatari Emaki* (Biography of the Monk Saigyō). The inspiration for the energetic divinities that appear on his large decorative screen *Fūjin-Raijin* (God of Wind and God of Thunder), for example, could well have been the storm gods found in the thirteenth-century *Kitano Tenjin Engi* (Legends of Kitano Tenjin Shrine) or the Muromachi-period *Kiyomizu-dera Engi*

(Legends of Kiyomizu-dera, Plate 113). His genius lay in an ability to rework the themes and ideas of *yamato-e* and the *emaki* into a uniquely personal and dynamic style. Ogata Kōrin, in turn, was nurtured on the classical arts of Japan; following in the footsteps of his master Sōtatsu, he created works of great decorative grace and distinction.

With the growth of a popular culture during the Momoyama period came the development of yet another type of art, genre painting, in which scenes of daily life and customs form the major themes. Although genre scenes were usually incidental in *emaki,* certain types of Momoyama genre painting, such as the representation of annual ceremonies and events and outdoor entertainments, may be traced to earlier

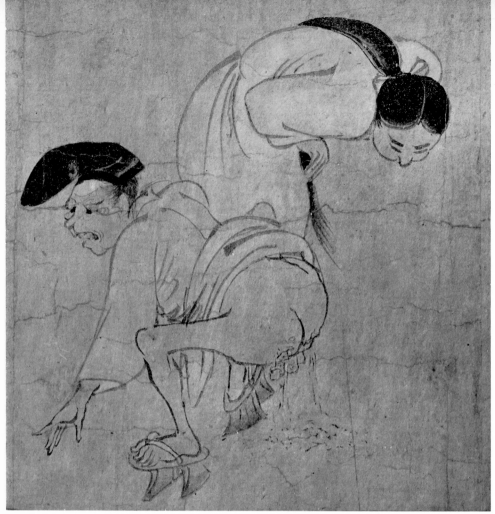

27. Yamai no Sōshi. *Kamakura period, 12th century. Sekido Collection, Aichi Prefecture.*

handscrolls. *Ukiyo-e* ("pictures of the floating world") developed in turn from Momoyama genre painting of domestic scenes, festivals, picnics, artisans, entertainers, and beauties. *Ukiyo-e,* which is largely known to the West through its woodblock prints from the Edo period, dealt with the pleasures of ordinary people and was created for the bourgeoisie, a new class of art patrons with a new aesthetic. The emergence of *ukiyo-e* represents the final flowering of ideals nurtured in the tradition of *yamato-e:* an unswerving interest in people and in the human world, colorful abstract design, a love of things intensely Japanese, and a personal rather than metaphysic view of nature and the universe.

Emaki as an Art Form

The *emaki* as an art form displays numerous ingenious techniques devised by artists to overcome the limitations and utilize to the fullest the advantages of the handscroll format. It is in the analysis of these techniques and styles that we begin to see not only the interplay between the kind of literature and the mode chosen for its expression, but also the way in which *emaki* illustrations reflect Japanese culture and the Japanese view of the world.

Artists

Only a few extant *emaki* bear the names of the artists who produced them and their dates of execution, and almost no mention is made of artists' names in old records. The long period during which *emaki* were produced and the number created suggest that there were a great many artists, but not until about the time of the painter Sesshū (1420–1506) did it become customary for Japanese artists to sign and date their work. (Some religious *emaki* are dated, it is true, but this is not the case with the overwhelming majority of the secular works.)

The few *emaki* artists known through literary sources and extant scrolls include not only professional artists, but people such as the emperor and his family, nobles, court officials, scholarly priests, and monk-painters. *The Tale of Genji* states that members of the imperial family and many aristocrats were *emaki* artists. During the Heian period the nobility received training in

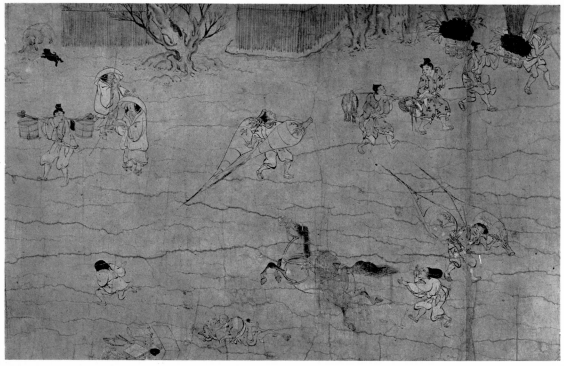

28. Saigyō Monogatari Emaki. *Kamakura period, 13th century. Ohara Collection, Okayama Prefecture.*

29–30. Saigyō Monogatari Emaki. *Kamakura period, 13th century. Ohara Collection, Okayama Prefecture.* ▷

painting and calligraphy as a matter of course, and many aristocratic "amateur" painters must have produced *emaki* of considerable merit. In fact, the dividing line between amateur and professional was very indistinct at this time.

The Tale of Genji also offers the names of some of the artists who actually lived and produced particular *emaki*. Kose Omi is reported to have painted the pictorial sections and Ki Tsurayuki to have inscribed the calligraphic portions of the *Taketori Monogatari Emaki* (Tale of the Bamboo Cutter), while Asukabe Tsunenori and Ono Michikaze are credited with the pictures and calligraphy, respectively, of the *Utsubo Monogatari Emaki* (Tale of Utsubo).

Most of the early professional artists were members of the Kyūtei Edokoro or the Bureau of Painting of the imperial court. Among them were Tokiwa Mitsunaga, Takashina Takakane, and Tosa Mitsunobu, who are said to have painted the *Ban Dainagon Ekotoba,* the *Kasuga Gongen Reigen Ki,* and the *Kiyomizu-dera Engi,* respectively. Some Buddhist monks were also professional artists; they painted religious pictures in the ateliers of their temples, and sometimes produced *emaki* as well. Shiba Rinken, the artist of the *Daibutsu Engi* (Legends of the Great Buddha), for example, was a Buddhist monk who was part of the Kōfuku-ji workshop in Nara. En'i, the artist of the *Ippen Shōnin* (Pictorial Biography of the Monk Ippen) scrolls, who worked in the Kankikō-ji, and Rengyō, who painted the *Tōsei Eden* (The Eastern Journeys of Ganjin), are also said to have been monks.

From late Muromachi times on there were, in ad-

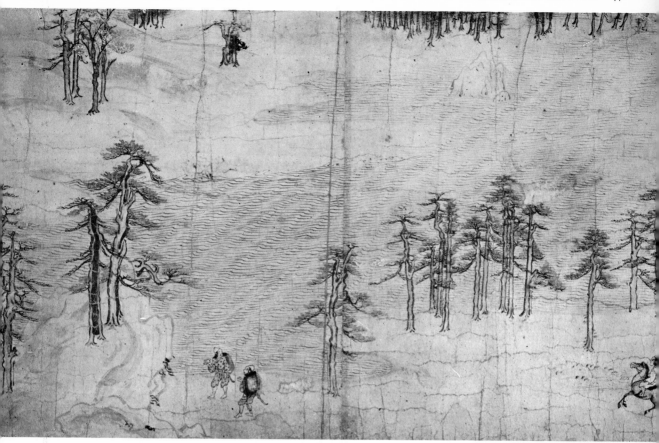

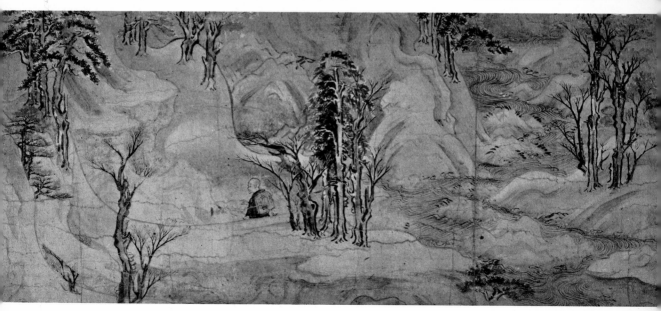

32. Tennō Sekkan Daijin Ei. *Kamakura period, 13th century. Imperial Collection, Tokyo.*

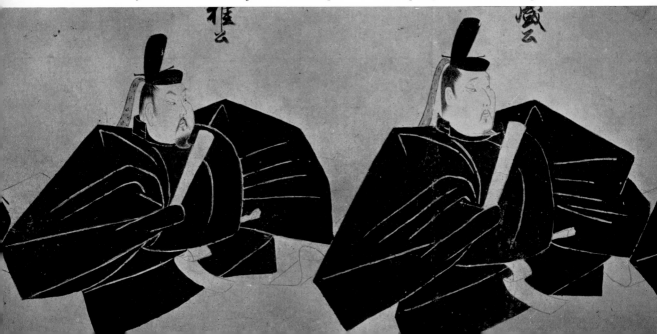

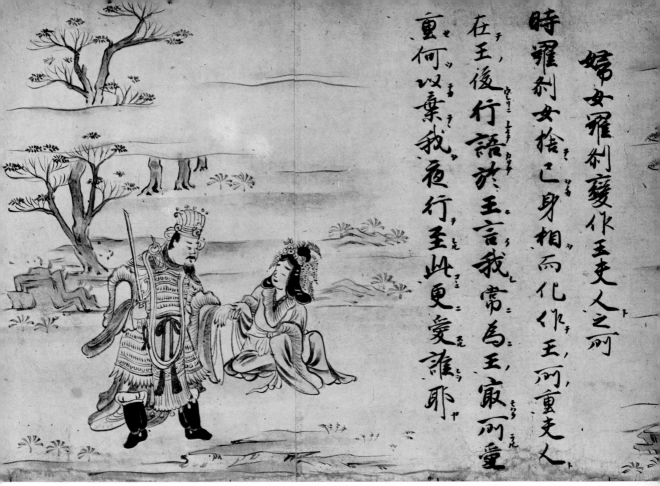

婦女羅刹變作玉夫人之䫞
時羅刹女捨己身相而化作玉䫞重夫人
在王後行語於玉言我常為玉敬䫞愛
何以棄我夜行至此更愛誰耶

37. Jūni Innen Emaki (Scroll of the Twelve Fates). Religious. Kamakura period, 13th century. Nezu Art Museum, Tokyo.

finishing touches. It also appears that the composition was sometimes changed while the pigments were being built up.

Color is, of course, paramount in emaki created by the tsukuri-e method. The final work emphasizes the blending and the sharpness of the colors; the fine, unaccented outlines are never conspicuous. They are used simply to border the flat, painted planes and do not stand out by variation in thickness or intensity of ink. Instead, the heavily and elegantly painted colors create the total effect. The tsukuri-e technique was used not only for the Genji scrolls but also for the Nezame Monogatari Emaki, the Murasaki Shikibu Nikki Emaki, and other scroll paintings based on works of literature; all these emaki were created in the onna-e style.

A representative polychrome emaki that emphasizes line rather than color is the Shigi-san Engi. In contrast to the Genji scrolls, the Shigi-san scrolls emphasize line drawing, for which thin color washes clarify linear effects. Other emaki that belong to this group include the Gaki Zōshi (Scroll of Hungry Ghosts), the Jigoku Zōshi (Scroll of Hell), and the Yamai no Sōshi; all of them are otoko-e, lively narratives full of characters from all social classes.

In contrast to the Genji and the Shigi-san emaki, both of which may be easily categorized, a great many handscrolls emphasize color and line equally. This synthetic style became popular and was carried to sophisticated heights in the early Kamakura period (late twelfth to mid-thirteenth centuries). The Ban Dainagon Ekotoba, the Heiji Monogatari Emaki, and the Kegon-shū Soshi Eden (Biographies of the Patriarchs of the Kegon Sect) are outstanding works in this group of scroll paintings.

38. Obusuma Saburō Ekotoba. *Kamakura period, 13th century. Asano Collection, Tokyo.*

• MONOCHROME EMAKI. The *hakubyō* or "white pictures" (also called *shira-e*) are *emaki* drawn almost exclusively in black ink. Except for slight dots of red on the lips of individuals, and sometimes *shōboku* (a brownish-tinged black ink) on hair, headdresses, and furnishings, there is no color. Masterpieces of the monochrome *emaki* include the *Chōjū Jimbutsu Giga*, the *Makura no Sōshi Emaki*, the *Takafusa-kyō Tsuya-kotoba Emaki* (Love Letters of Lord Takafusa, Plates 76, 77), and the *Zuijin Teiki Emaki*.

The *Chōjū Jimbutsu Giga* is an ink drawing characterized by various shades of black ranging from jet to light gray, with lines that exhibit dynamic variations in thickness. By means of the rapidly drawn lines, the artist has created a simple yet eminently successful drawing. Line in this scroll painting does not carry the somewhat negative connotation of border or outline; rather, it is the basis for the lively and dynamic composition.

The *Makura no Sōshi Emaki,* a scroll painting in the courtly tradition, is characterized by precise, sharp, firm lines; line is the dominant compositional element and the black ink controls the picture plane strongly and definitively. We see no casual, sketchy effect here. Hard and brilliant, this work has much in the way of visual interest; the use of lines and the variation in ink tones from pale, diluted black to jet black combine to make it a fascinating, almost abstract composition. It is unexcelled in its presentation of decorative detail such as screens, lattice doors, and other architectural elements; and the manner in which the court ladies' flowing hair is painted in jet black, their eyebrows

39. Ippen Shōnin Eden. *Kamakura period, 13th century. Kankikō-ji, Kyoto.*

40. Ippen Shōnin Eden. *Kamakura period, 13th century. Kankikō-ji, Kyoto.*

41. Kibi Daijin Nittō Ekotoba. *Kamakura period, 13th century. Museum of Fine Arts, Boston.*

blurred, and a small amount of red applied to their lips heightens the visual effect. The *Makura no Sōshi* recreates the Heian court world in black and white, just as the *Genji* scroll painting does in color.

Although the lines of the *Zuijin Teiki* are of consistent thickness, this work possesses the spirited force and fluency of the *Chōjū Jimbutsu Giga*. The facial expressions of its characters are full of individuality, and it is charged with a feeling of freedom and liveliness. One characteristic that distinguishes this scroll from the *Chōjū* and *Makura* scroll paintings is that the faces of the characters as well as the trappings of the horses are faintly colored.

Perspective

The perspective found in Western painting is un-

known in *emaki* art. This is partly the result of the limited width of the *emaki* format: geometrical accuracy, if enforced, would have severely inhibited the artist in his depiction of characters and the narrative. Although *emaki* artists exploited the potential of the horizontal handscroll to the fullest, they always faced certain limits in terms of organization of space. Their solutions to these problems of compositional arrangement, however, are unique and effective.

One method, used especially to portray the intimate lives of the aristocrats, is termed *fukinuki-yatai*, or "blown-away roofs." Because the *emaki* format is limited in width, it was necessary to employ a diagonal, downward-looking perspective in order to show a number of people and objects in the same scene. Roofs and ceilings, as well as some room partitions, were then radically dispensed with in portrayals of interior

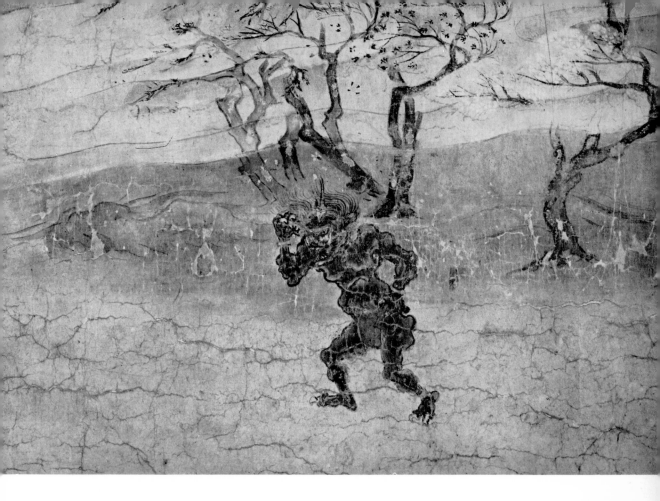

court scenes so that the viewer could enter directly into the intimate personal relationships that are their focus. Although this device is a nonrealistic abstraction, it nevertheless heightens the viewer's dramatic perception and involvement with what is being depicted (Plates 7, 71).

The technique of slanting lines (*shasenbyō,* literally "oblique line depiction") is used in *emaki* of court origin and inspiration: roofs, verandas, and walls are drawn with parallel diagonal lines, a technique that uses to the fullest advantage the limited depth of the format. Most of the slanted lines are drawn from the upper right to the lower left, carrying the eyes of the viewer in the right to left order in which the scroll is unrolled (Plates 70, 73).

The *emaki* artist sometimes seems to suggest or stress the emotion inherent in a scene by reordering these slanted lines to create a disturbing visual effect. Scenes characterized by nearly vertical lines that are charged with a sense of drama and tragedy include the "Kashiwagi" (Plate 7) and "Law" (Plate 2) scenes from *The Tale of Genji,* both depictions of moments of sorrowful reflection. Slanted lines drawn in reverse, from upper left to lower right, as in Plate 11, may also suggest the unease underlying a certain scene. However, the relationship between the intensity and direction of the slanted lines and the emotional content of a scene has yet to be systematically proved.

Scale

A departure from the Western tradition appears in terms of scale as well as in perspective. For example, *emaki* heroes are often portrayed in closeup views as

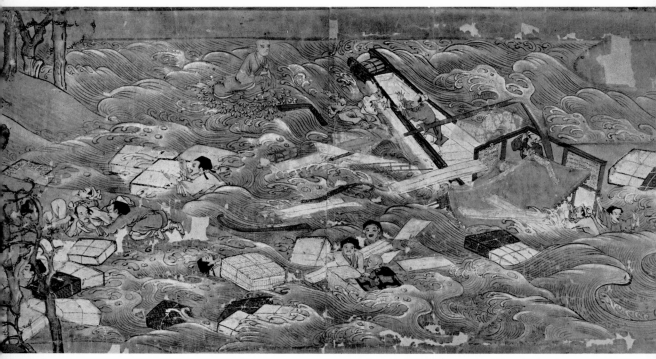

42. Tōsei Eden. *Kamakura period, 13th century. Tōshōdai-ji, Nara.*

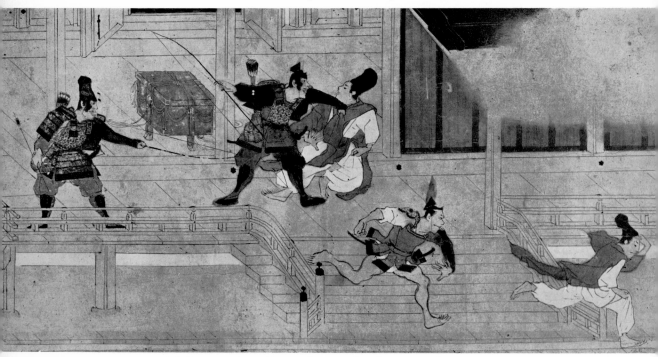

43. Heiji Monogatari Emaki. *Kamakura period, 13th century. Tokyo National Museum.*

hook-line nose, straight eyebrows, red-dotted lips, and plump cheeks, seems to conceal all emotion (Plates 6, 51, 77). Although devoid of strong emotional and physical characteristics, these faces can have the same deep effect on the viewer as Nō masks, which suggest human feelings only by allusion and association.

As in the Nō drama, subtle changes in expression and posture—perhaps a slight variation in the tilt of a head—express grief, anguish, or other strong emotion. Holding a sleeve to one's face, for instance, indicates weeping and sorrow (Plates 2, 75, 105). For the most part, however, the viewer must use his knowledge of the events portrayed and his sensitive imagination to respond to the drama inherent in each scene.

There is a sense of static beauty in the portrayal of these aristocrats, whose figures are hidden under thick layers of garments and whose faces and movements reflect almost superhuman control of the often turbulent emotions that seemed to govern their lives. Almost all the court ladies, for example, are shown sitting; this posture is symbolic of entire lives lived within the dimly lit interiors of various palatial residences, dependent on the generosity and attention of men who were free to go elsewhere within Heian polygamous society.

The people in scrolls such as the *Shigi-san Engi,* by contrast, seem to be in continuous motion. Their facial expressions, which are vividly emphasized, depicted in an almost caricaturelike fashion, show a wide range of feelings. Such concern with human emotions and "realistic" portraiture was an element in *emaki* art that indicated the emergence of new cultural trends de-

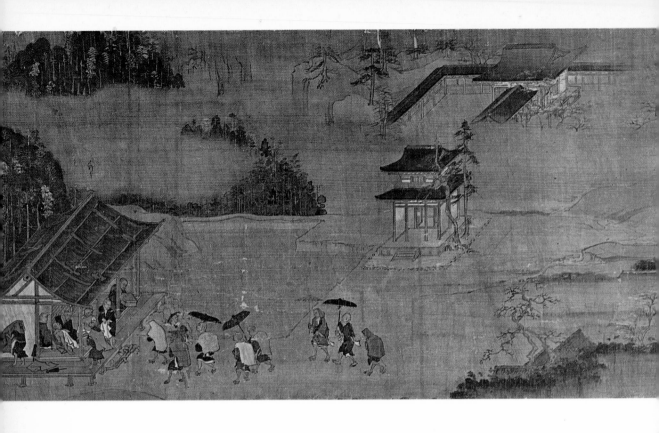

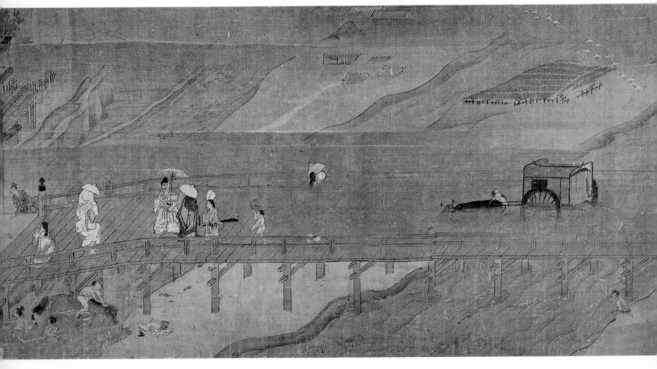

3

Emaki as Historical Mirrors

Because *emaki* are one major form of painting from the Heian, Kamakura, and Muromachi periods, they prove invaluable in studying the lives and customs of medieval Japanese. All manner of people from all walks of life are portrayed going about their daily tasks and experiencing the emotional complexities of life. Nearly all the stories depicted in the scroll paintings take place in Japan, although a few are staged in China, Korea, Central Asia, and India.

One important fact to bear in mind when considering *emaki* as social historical documents, however, is that they usually depict people and structures as they looked at the date of the production of the *emaki*, even when the narratives deal with people and events of several centuries earlier. For example, the Ishiyama-dera temple was built during the Nara period, but the

construction scene that appears in the *Ishiyama-dera Engi* (Legends of Ishiyama-dera, Plate 74), depicts the event as it would have looked had it taken place during the Kamakura period.

Literally thousands of people come to life on the extant *emaki* scrolls. The majority are Japanese, and although there are many historical personages portrayed, others are creations of the painters' imaginations or characters from fiction. Commoners—farmers, fishermen, craftsmen, and entertainers—appear in *emaki* dealing with legends of temples and shrines, popular narratives, and folk tales, but are seldom represented in the scrolls that illustrate literary works of court origin, such as *The Tale of Genji*, or in war chronicles like the *Mōko Shūrai Ekotoba*.

Even in the scrolls in which they do appear, lower-

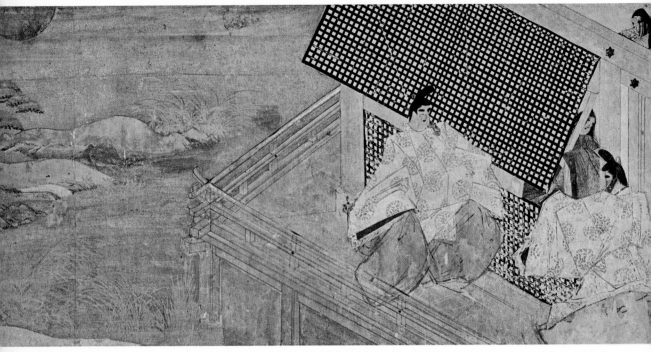

58. *Murasaki Shikibu Nikki Emaki. The diary of Murasaki Shikibu, the author of* The Tale of Genji, *inspired this emaki, done in the elegant* tsukuri-e *technique using opaque colors built up in layers. This scene takes place on an autumn evening in 1008 after the visit of Emperor Ichijō to the mansion of Fujiwara Michinaga. Lady Murasaki is in her room on the eastern side of the corridor when two courtiers approach and tease her to open her lattice door. Murasaki is shown in the inner part of the room, at the upper right. The use of diagonal lines in spatial perspective is apparent in this scene, and the black and white grillwork of the lattice door provides an effective, almost abstract backdrop for the gentlemen in their magnificent court garb. Kamakura period, 13th century. Gotō Art Museum, Tokyo.*

class people are usually not the leading characters; these roles are largely the prerogative of aristocrats, warriors, and priests. Nevertheless, genre scenes of ordinary people add a great deal of interest and charm to scroll paintings. For example, some of the most appealing sections of the *Shigi-san Engi* occur in the third scroll, which follows an old nun searching for her brother: women draw water from a well and wash clothes (Plate 15) and a mother nurses her baby while an elderly man and woman chat with the nun by the roadside (Plate 19).

Some scroll paintings do portray commoners as heroes—for example, the *Tōhoku-in Shokunin Uta-awase Emaki* (Plate 69) and the *Sanjūni-ban Shokunin Uta-awase Emaki* (Poetry Contest in Thirty-two Rounds by Members of Various Professions, Plate 98). These

emaki depict individual craftsmen and tradesmen at work, and each portrait is accompanied by a *waka* poem. This type of scroll painting may have been created to chronicle the various new trades and crafts that developed as the economy grew in complexity during the late Kamakura and Muromachi periods.

Emaki are therefore an extremely useful source for a study of the different trades and crafts of medieval Japan. The sixteenth-century *Shichijūichi-ban Shokunin Uta-awase Emaki* (Poetry Contest in Seventy-one Rounds by Members of Various Professions), for example, depicts 142 craftsmen, among them sword-sharpeners, sakè brewers, horse dealers, wizards, fishmongers, dice makers, armorers, bamboo-blind makers, doctors, astrologers, and sumo wrestlers. The attitudes and dress of the various characters depicted in

Boki Ekotoba
(Biography of the Priest Kakunyo)
10 scrolls. Nishi Hongan-ji, Kyoto. Kamakura period
(14th century). Important Cultural Property.

This is a pictorial biography of Kakunyo (1270–
1351), the third chief priest of the Hongan-ji in Kyoto,
one of the head temples of the True Pure Land sect
(Jōdo Shinshū). Done in the traditional *yamato-e* style,
this *emaki* supplies much important information con-
cerning the way of life and the customs of the period.
The artists who created the scrolls were Fujiwara Hisa-
nobu (first and seventh scrolls), Fujiwara Takaaki
(second, fifth, and sixth scrolls), and Fujiwara Taka-
masa (third, fourth, ninth, and tenth scrolls). The
painter of the eighth scroll is unknown.

This *emaki* was loaned to the household of the sho-
gun at the request of the shogun Yoshimitsu (r. 1368–
94). In 1481, the *emaki* was returned to its owner, but
the first and seventh scrolls were missing. In 1482,
Fujiwara Hisanobu repainted these two scrolls to re-
place the lost ones. (Plate 83)

Chōjū Jimbutsu Giga
(Scroll of Frolicking Animals and People)
4 scrolls. Kōzan-ji, Kyoto. Heian and Kamakura pe-
riods (12th and 13th centuries). National Treasure.

Each of the four scrolls in *Chōjū Jimbutsu Giga* deals
with a different subject. Monkeys, hares, and frogs
mimic human beings with great enjoyment in the
first and most popular scroll. The second scroll, which
is called "Sketches of Birds and Animals," consists of
cursory drawings of fifteen kinds of animals, both real
and imaginary, such as horses, cows, cocks, lions,
dragons, and *kirin*. The third scroll, "Caricatures of
Men, Birds, and Animals," is divided into two sec-
tions: the first half depicts priests and laymen gam-
bling; the second half shows monkeys, hares, and frogs
imitating people, as in the first scroll. The fourth
scroll, "Caricatures of Men," is similar to the first
half of the third scroll and depicts priests and laymen
enjoying various activities. Different interpretations
have been given to these scrolls, but since there is no
accompanying text, no explanation proves uncon-
troversial.

The entire *emaki* is executed in ink alone. The work
has been attributed to the monk Kakuyū (1053–1140),
who is often given the nickname Toba Sōjō, but there
is no firm evidence to support this assertion. It is likely
that different artists worked on these *emaki*. The date
of production is set in the late Heian period (mid-
twelfth century) for the first two scrolls and the early
Kamakura period for the last two scrolls. The year
1253 is inscribed at the end of the third scroll. (Plates
24–25, 56)

Dōjō-ji Engi
(Legends of Dōjō-ji)
2 scrolls. Dōjō-ji, Wakayama Prefecture. Muromachi
period (16th century). Important Cultural Property.

During the reign of Emperor Daigo, in the early
tenth century, a married woman fell in love with a
young monk who had come from the northern part
of Honshū to visit the three Kumano shrines. The
monk fled from her, but the woman, disguising her-
self as a giant snake, pursued him. He hid inside the
bell of the Dōjō-ji, but the snake-woman wrapped
herself around the bell and blew fire into it until the
monk was burned to death. A memorial service later
held by the monks of the temple made it possible for
the woman and the monk to go to heaven. The story
is illustrated in continuous narrative fashion and con-
versations are written on the pictures, which eliminates
the necessity for interpolated textual sections. (Plates
108, 109–110)

E Inga-kyō
(Illustrated Sutra of Cause and Effect)
1 scroll. Jōbon Rendai-ji and other temples, Kyoto.
Nara period (8th century). National Treasure.

This *emaki* illustrates the *Sutra of Cause and Effect in
the Past and Present,* which relates the activities of the
Buddha in his previous existence and describes various
legends about the life in which he finally achieved
Buddhahood. The scroll reflects the style of an original
Chinese version in that the sutra is copied in "regular-
style" *(kaisho)* characters of the T'ang period on the
lower half of the horizontal format, while the upper
portion is reserved for illustrations.

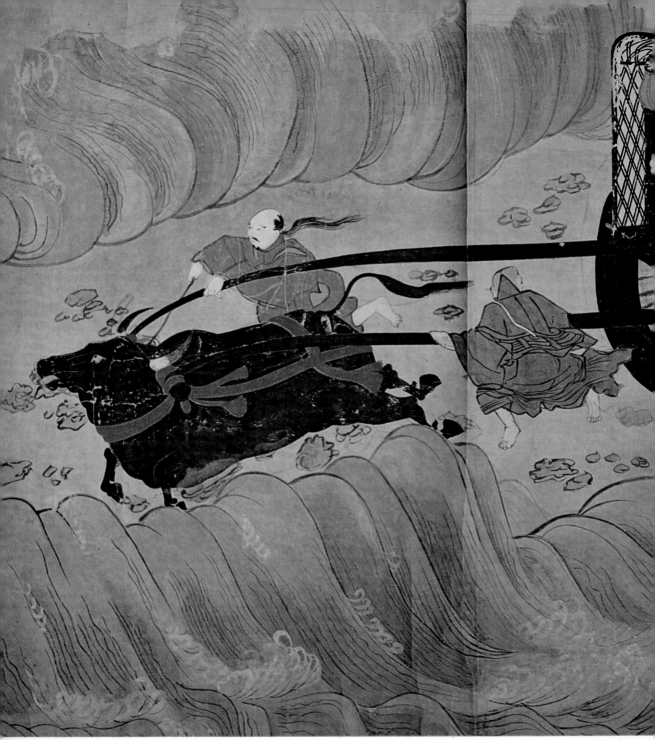

78. Kitano Tenjin Engi. *Scroll V. The Buddhist monk Son'i of the Hōshōbō temple on Mount Hiei is summoned to Kyoto by the emperor to pacify the spirit of Sugawara Michizane, who before his death had declared that his enemies would be haunted until a shrine was built for him (see also Plates 75, 118). On his journey Son'i finds the Kamo River flooded because of a thunderstorm caused by the*

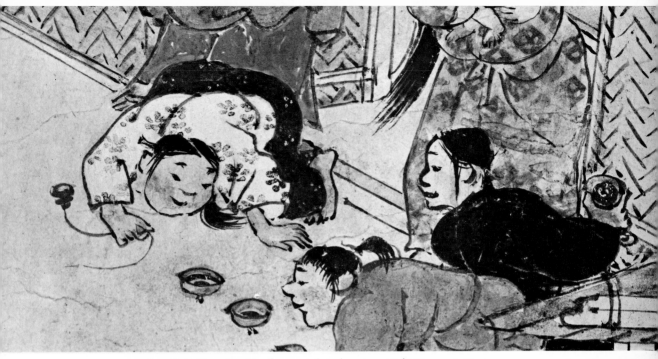

83. Boki Ekotoba. *Kamakura period, 14th century. Nishi Hongan-ji, Kyoto.*

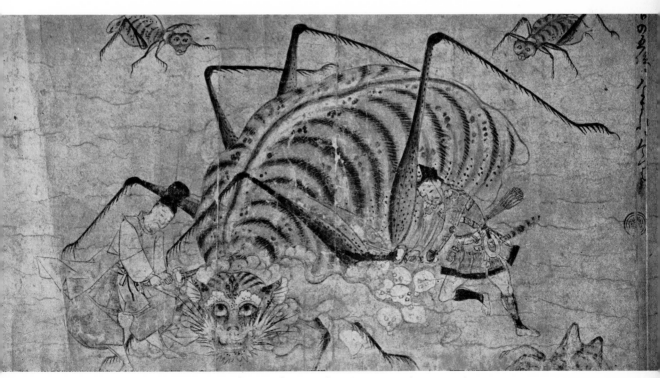

84. Tsuchigumo Zōshi. *Kamakura period, 14th century. Tokyo National Museum.*

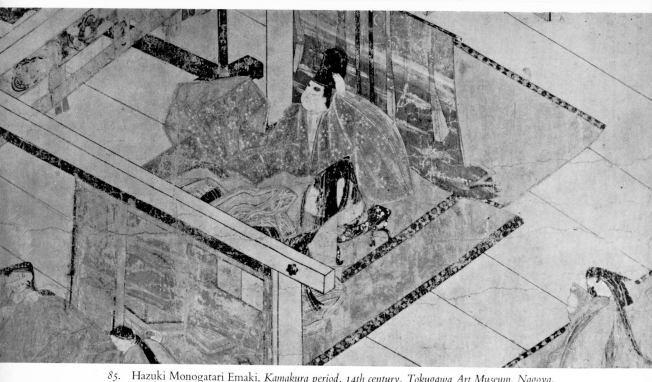

85. Hazuki Monogatari Emaki. *Kamakura period, 14th century. Tokugawa Art Museum, Nagoya.*

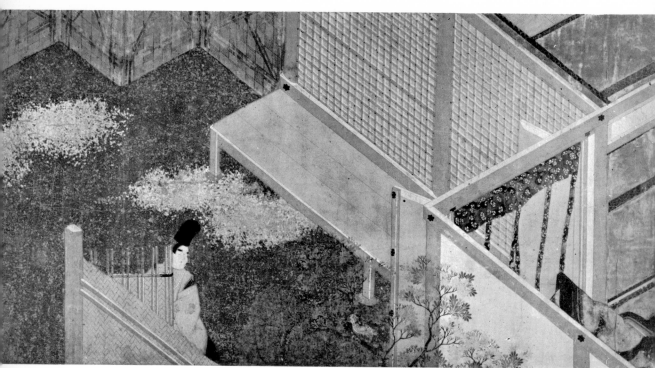

86. Ise Monogatari Emaki. *Kamakura period, 14th century. Kubo Collection, Osaka.*

Other versions of this illustrated Nara-period sutra have been preserved, including one scroll in the Hōon-in in Kyoto, one in the Tokyo University of Arts, and another presently in the hands of the Cultural Properties Protection Commission, Tokyo. All are painted in a simple style derived from paintings of the Six Dynasties period (222–589) in China. (Plate 1)

Eshi no Sōshi
(Story of a Painter)
1 scroll. Imperial Collection, Tokyo. Kamakura period (14th century).

In an ancient tale, a poor painter is appointed the lord of Iyo Province and invites all his relatives to a celebratory feast. However, his fief is stolen soon afterward, and he is left without any source of income. He seeks the assistance of a nobleman, an official magistrate of painting at the Hōshō-ji, but this proves useless. Poor and helpless, the painter makes his son a postulant at a temple of the Shingon sect, and he becomes a Buddhist himself. (Plate 91)

Fukutomi Zōshi
(Story of Fukutomi)
2 scrolls. Shumpo-in, Kyoto. Muromachi period (15th century). Important Cultural Property.

Hidetake, a poor old man, was persuaded by his wife to pray to Dōsojin, a Shintō deity who protects travelers. He dreamed that the deity gave him a small bell. A fortuneteller interpreted the dream and told Hidetake that he would become rich aided by an unexpected voice from within himself. Soon afterward, he learned to dance to the musical sounds of his farts. He was asked to demonstrate his unusual talent to some nobles and he soon became rich because of the damask, brocade, and gold he received from them. Fukutomi, his old neighbor, also a poor man, envied Hidetake's prosperity and acceded to his wife's demands that he become Hidetake's pupil. Hidetake accepted Fukutomi as his student and gave the latter morning-glory seeds which, unbeknown to Fukutomi, induce diarrhea. Consequently, Fukutomi could not control his bowels during the show he performed in front of an assistant chief of the imperial guards,

and he returned home severely beaten. Fukutomi's enraged wife attacked Hidetake in the street and bit him. In this *emaki,* one of the best folk-tale scrolls, conversations are written right onto the illustrations. (Plates 100, 101, 114)

Gaki Zōshi
(Scroll of Hungry Ghosts)
1 scroll. Tokyo National Museum, Tokyo. 1 scroll. Kyoto National Museum, Kyoto. Kamakura period (12th century). National Treasure.

This *emaki* deals with the grotesque hungry ghosts *(gaki)* who haunt various places in hopes of relieving their hunger and thirst and of achieving a more auspicious rebirth. The scroll in the Tokyo National Museum depicts hungry ghosts who crave sex, newborn babies, and excrement; ghosts who run wildly in the wilderness; ghosts who eat hot ashes in the cremation grounds and who wander among the tombs; and ghosts who crave water.

The Kyoto National Museum scroll includes illustrations based on a Buddhist sutra, the *Shōhō Nenjo-kyō,* which explains the six realms of rebirth *(roku-dō)*. In Buddhist doctrine, a living being is doomed to the wheel of birth and death and to rebirth in one of these six realms until he achieves enlightenment and release from the bondage of life. The scroll includes such stories as an account in which a disciple of Buddha aids a mother who has been reborn in the realm of the hungry ghosts, the story in which the Buddha succors five hundred ghosts craving water by the Ganges River in India, and the story in which Ananda relieves ghosts with flaming mouths.

Although these two scrolls were painted by different artists, the styles are similar: the lines in both are freely executed and the coloring is faint. The Buddhist doctrine of the six painful realms of rebirth, which is also reflected in the *Jigoku Zōshi* (Scroll of Hell), was widely disseminated among the people during the end of the Heian period and the beginning of the Kamakura period, when society was in a state of unrest because of civil strife and natural disasters. (Plates 35, 49)

Genji Monogatari Emaki
(The Tale of Genji)

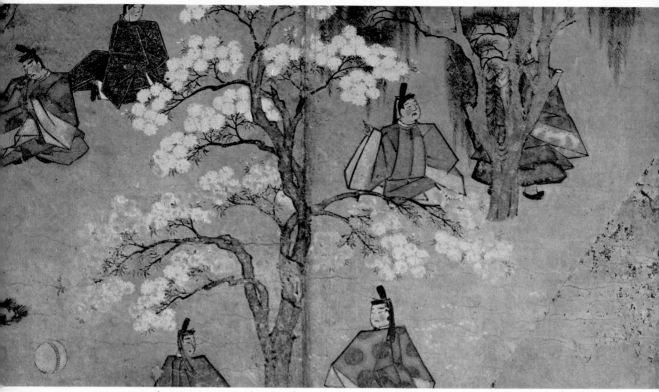

87. Nayotake Monogatari Emaki. *Kamakura period, 14th century. Kotohira-gū, Kagawa Prefecture.*

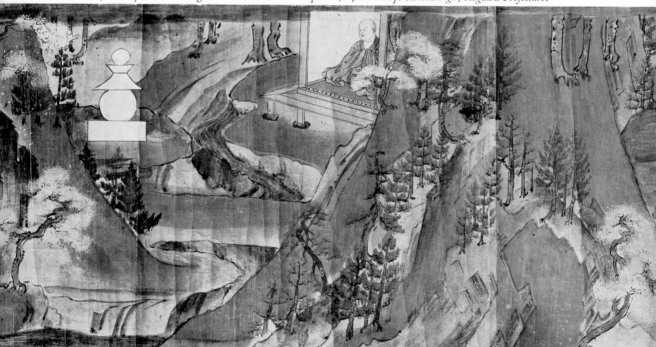

88. Kōbō Daishi Gyōjō Ekotoba *(Biography of Priest Kōbō Daishi). Kamakura period, 14th century. Kyō-ō Gokoku-ji, Kyoto.*

and the lady Bifukumon'in to the mansion of Taira Kiyomori at Rokuhara. (Plates 43, 99)

Hōnen Shōnin Eden
(Biography of the Monk Hōnen)
48 scrolls. Chion-in, Kyoto. Kamakura period (14th century). National Treasure.

This *emaki* deals with the life of Hōnen (1133–1212), founder of the Jōdoshū (Pure Land) sect of Buddhism. It also contains biographical sketches of his disciples. Visual representations of the important doctrines of Hōnen make it unique among the pictorial biographies of religious leaders. Tradition has it that Shunshō, the chief priest of the temples of Mt. Hiei, compiled material for the *emaki* from several Buddhist scriptures by order of ex-Emperor Gofushimi. Its production began in 1307 and took ten years, with different artists working on the text and the pictures. Despite various styles, the entire work is successfully executed in bright colors and holds together well as a single unit. It portrays people from all walks of life and is thus an important source for the study of the customs of the time. (Plates 60-61)

Ippen Shōnin Eden
(Pictorial Biography of the Monk Ippen)
11 scrolls. Kankikō-ji, Kyoto. 1 scroll (7th scroll). Tokyo National Museum, Tokyo. Kamakura period (13th century). National Treasure.

This is a pictorial biography on silk of Ippen (1239–89), founder of the Jishū, a branch of the Pure Land sect. Ippen spent most of his life wandering through the country urging people, rich and poor alike, to invoke the name of Amida Buddha in order to obtain salvation. He led both priests and laymen in the *odori nembutsu,* the invocation of the name of Amida Buddha while marching in a circle to the accompaniment of musical instruments such as the gong or drum.

The biographical text was written by Seikai, an adherent of Ippen and the founder of the Kankikō-ji. The illustrator was En'i, who held the title of Hōgen, an honorary title given by the emperor to scholarly Buddhist priests. Completed in 1299, ten years after Ippen's death, the work is regarded as a reliable record

of the customs and habits of his time. This scroll painting is particularly noteworthy for the scenic panoramas that provide the background illustrations for Ippen's travels. In fact, the figures often seem engulfed by the landscape, in the Chinese fashion, although the artistic treatment of the landscape lies definitely within the *yamato-e* style. (Plates 39, 40, 52, 53)

Ise Shin Meisho Uta-awase Emaki
(Poetry Contest on Newly Selected Scenic Spots in Ise)
1 scroll. Ise Shrine Administration Agency, Mie Prefecture. Kamakura period (13th century). Important Cultural Property.

In the Einin era (1293–99), the priests of the Ise Shrine selected ten scenic spots in the vicinity of their establishment and held a *waka* poetry contest in which the beauty of these locations was articulated. The prize poems were illustrated and made into two *emaki* scrolls, of which only the second remains. Unlike most *emaki,* it is devoted solely to landscape. (Plate 115)

Ishiyama-dera Engi
(Legends of Ishiyama-dera)
7 scrolls. Ishiyama-dera, Shiga Prefecture. Kamakura period (14th century). Important Cultural Property.

This *emaki* illustrates the legendary origin of the Ishiyama-dera, which the monk Rōben established in the mid-eighth century with Nyoirin Kannon as its principal deity. After depicting many miraculous occurrences, the scroll ends with Emperor Godaigo's dedication of a manor to the temple in commemoration of his enthronement.

It is generally agreed that the first three scrolls were painted by Takashina Takakane, the fourth by Tosa Mitsunobu, and the fifth by Awataguchi Takamitsu. The last two of the seven are later additions painted by Tani Bunchō during the Edo period. Thus the work of three different periods—the Kamakura, the Muromachi, and the Edo—is represented in this scroll painting. (Plates 67, 74)

Jigoku Zōshi
(Scroll of Hell)
1 scroll. Tokyo National Museum, Tokyo. 1 scroll.

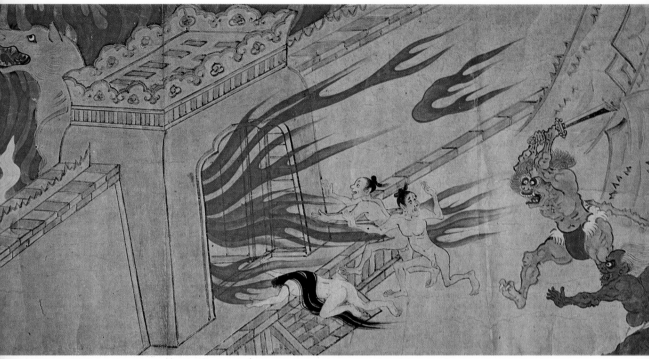

94. Yata Jizō Engi. *This scroll painting features the legends of Yata-dera temple and its principal deity Jizō, and includes a section on the high priest Mammei's travels in hell, from which this scene is taken. Here, two vicious demons, with two-toed feet, grotesque faces, and overly muscular bodies, are forcing unfortunate sinners into the fires of hell. Kamakura period, 14th century. Yata-dera, Kyoto.*

95. Zuijin Teiki Emaki. *The prestigious imperial cavalry, which escorted the nobility on various occasions, is the subject of this ▷ exquisite monochrome scroll painting. Only the faces and the trappings of the horses are faintly colored. Although several cavalrymen from various periods are portrayed, the emaki has no plot. In this scene Hata Hisanori is calmly engaged in taming a spirited horse. His face is painted in the nise-e manner, a modified form of realistic portraiture that developed from the late twelfth century onward. Kamakura period, 13th century. Okura Museum, Tokyo.*

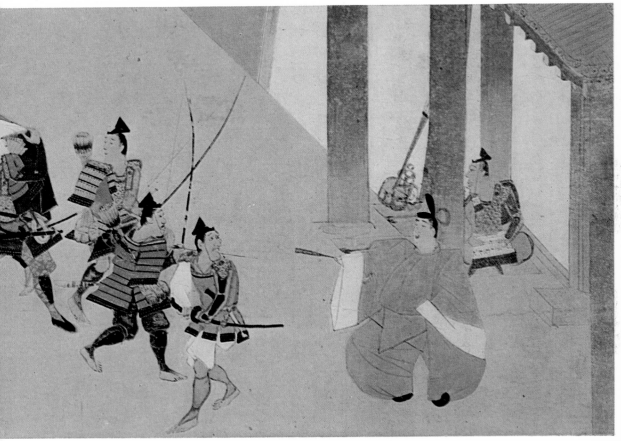

example of Kamakura emaki art. Here Emperor Nijō, disguised as a court lady, tries to escape from the Sakuhei Gate at the back of his palace and is questioned by rebels. Kamakura period, 13th century. Tokyo National Museum.

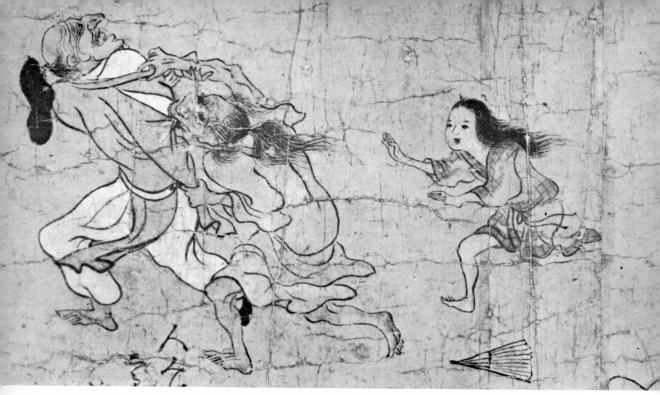

100. Fukutomi Zōshi. *Muromachi period, 15th century. Shumpo-in, Kyoto.*

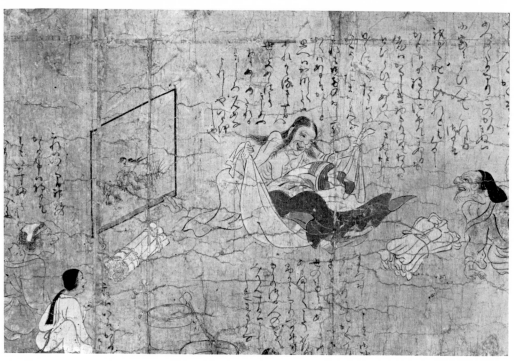

101. Fukutomi Zōshi. *Muromachi period, 15th century. Shumpo-in, Kyoto.*

Nara National Museum, Nara. Kamakura period (12th century). National Treasure.

This *emaki* depicts different realms within the Buddhist hell, in which there are eight principal hells and sixteen subsidiary hells for each principal one. Each scene in these scrolls is preceded by a commentary describing it. The Tokyo National Museum scroll illustrates four subsidiary infernos within the hell of screams as described in the *Shōhō Nenjo-kyō*. They are the hell of the dog and eagle of hot iron; the hell of worms; the hell of smoke, fire, and fog; and the hell of rain, flame, and stones. The Nara Museum scroll depicts the infernos of excretion, measure, the iron mortar, the giant cock, black clouds, pus and blood, and the hell of foxes and wolves. These are seven of the eight infernos mentioned in another sutra, the *Kisei-kyō*. Both these sutras describe the six realms of existence and focus on hell as one of these horrible regions.

The scroll paintings depict the suffering of those who committed such sins as theft, murder, or adultery in their previous existences. Despite their often disgusting subject matter, many people are attracted by the power and grandeur of these scrolls. Although the artist is not known, the contents and style of the work lead one to believe it was done by a Buddhist monk-painter active at the end of the twelfth century. (Plate 46)

Jūnirui Emaki
(Poetry Contest of the Twelve Zodiac Animals)
3 scrolls. Dōmoto Collection, Kyoto. Muromachi period (15th century). Important Cultural Property.

The twelve birds and animals of the zodiac held a poetry competition and appointed the deer as judge. The badger, envious of the deer because everyone entertained him, tried to force the other animals to make him a judge so that he could enjoy the same privileged position. He not only failed in his endeavor but was roundly rebuked. Feeling insulted, he gathered together his kin and attempted a nighttime raid of revenge, but this also ended in failure. The badger finally entered the priesthood of the Pure Land sect. (Plate 93)

Kasuga Gongen Reigen Ki
(The Kasuga Gongen Miracles)
20 scrolls. Imperial Collection, Tokyo. Kamakura period (14th century).

These twenty scrolls were dedicated to the Kasuga Shrine in March 1309 by Saionji Kinhira (1264–1315), a member of the illustrious Fujiwara family and current Minister of the Left. Illustrating the miraculous virtues of the gods of the Kasuga Shrine, the tutelary divinities of the Fujiwara family, they begin with a scene in which a daughter of a lord of the old and honored Tachibana clan announces an oracle, and they end with the miracle of sacred fire flying into the shrine, which was purported to have occurred in 1304. The illustrations for the entire work were meticulously executed by Takashina Takakane, the head of the court atelier; the text was written by members of the clan. This scroll painting ranks as one of the masterpieces of the late Kamakura period. (Plates 89, 90)

Kegon Gojūgo-sho Emaki
(The Pilgrimage of Zenzai Dōji in Fifty-five Stages)
1 scroll. Tōdai-ji, Nara. Heian period (12th century). National Treasure.

This scroll painting is also called the *Zenzai Dōji Emaki* or *The Scroll of the Boy Zenzai* because it depicts the travels of Zenzai who, instructed by Monju, the Bodhisattva of wisdom, journeyed around India inquiring of fifty-three saints and deities the way to salvation. The chapter in the *Kegon Sutra* from which this *emaki* was adapted tells us that the boy met his master again at the end of his pilgrimage, was led to the Bodhisattva Fugen, the right-hand attendant of Sākyamuni Buddha, and finally attained enlightenment.

In a square above each portion of the *emaki* is written the rank and name of each saint or deity, the location of his abode, and a description of the scene. Zenzai and the various saints and deities are depicted in either landscape or palatial settings. Japanese taste predominates in the light brushstrokes and faint, delicate coloring; the architectural designs and the clothing, however, are of Chinese inspiration. Part of this *emaki* was cut up during the Meiji era (1868–1912), and the frag-

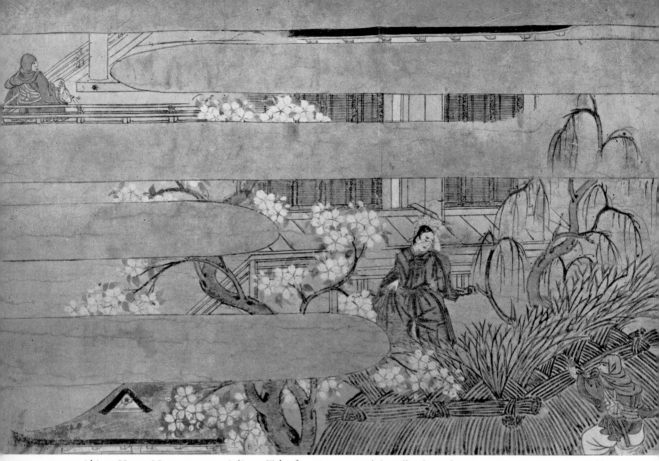

102. Aki no Yo no Nagamonogatari *(Long Tale of an Autumn Night). Folk tale. 15th century. Kōsetsu Collection, Osaka.*

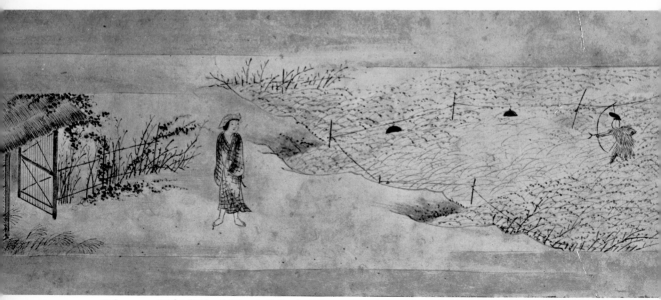

103. Bakemono Zōshi *(Tale of Ghosts). Folk tale. Muromachi period, 16th century. Mizukami Collection, Tokyo.*

This *emaki* illustrates two miraculous legends concerning the Thousand-armed Kannon (Senju Kannon), the principal deity of Kokawa-dera. The first miracle occurred in the eighth century and involved a hunter living in Kii Province. He set a trap in the mountains and later noticed a shining spot near it. He then built a hut there, hoping that at some future time he could obtain a Buddhist image and build a temple at the place. One day a boy came to his house and asked for lodging. The request was granted and the boy in gratitude offered to make a Buddhist image on the condition that the hunter would not visit the hut for seven days. On the eighth day the hunter returned and found a dazzling golden image of the Thousand-armed Kannon, but he could find no trace of the boy.

The second story concerns the sick daughter of a wealthy man living in Kawachi Province. A boy came to visit and cured her by reciting a magic spell from a sutra. He refused the treasure the wealthy man offered, but accepted a red skirt and a small knife from the daughter. He left, informing the family of his address: Kokawa, Naka County, Kii Province. The following year the wealthy man and his family visited the place and found a small hut on the mountainside. They opened the door and saw a resplendent Thousand-armed Kannon holding in its hands the red skirt that the daughter had given the boy the year before. Realizing that the boy was an incarnation of the Bodhisattva Kannon, the whole family entered monastic life. (Plate 45)

Komakurabe Gyōkō Emaki
(An Imperial Visit to the Horse Race)
1 scroll. Seikadō, Tokyo. 1 scroll. Kubo Collection, Osaka. Kamakura period (14th century). Important Cultural Property.

This *emaki* is based on the chapter "Horse Races" from the *Eiga Monogatari* or *Tale of Splendor,* a work written in the late eleventh century dealing with the history of the imperial court. The Seikadō scroll illustrates the visit of Jōtōmon'in Akiko, the dowager empress, to Kaya-no-in, the mansion of Fujiwara Yorimichi, on September 14th in the first year of Manju (1024). The Kubo scroll depicts the visit of Emperor Go-ichijō and his consort to the same mansion on September 19th of the same year. (Plate 79)

Makura no Sōshi Emaki
(The Pillow Book)
1 scroll. Asano Collection, Tokyo. Kamakura period (14th century). Important Cultural Property.

This scroll painting is based on the *Pillow Book (Makura no Sōshi),* a witty collection of impressions and events written by the learned and often acerbic court lady Sei Shōnagon in the early eleventh century. The scene showing the lady of the Shigeisa Palace visiting her sister, Empress Sadako, in the Ichijō Palace is among the seven scenes in this scroll.

The pictures are drawn almost exclusively in black ink, with darker tints of black for hair, eyebrows, and furniture, and a few faint touches of red for the lips. (Plates 73, 111)

Matsuhime Monogatari Emaki
(Tale of Matsuhime)
1 scroll. Tōyō University, Tokyo. Muromachi period (16th century).

This scroll painting depicts the story of a courtier who fell in love with and married Matsuhime, the daughter of an assistant chief of the imperial guard. His parents, however, did not approve of their son's marriage, since the girl had neither influential friends nor wealth. One day, when their son was away from home, they induced the bride to go out into a field of pampas grass, where one of their men killed her. The groom spent anguished days searching for his bride. One autumn evening, he saw her ghost and followed it into a thatched hut, where it told him the entire story. When dawn came, he found only a skull in the desolate field. Later, the young man became a monk and wandered over the countryside.

The painting was probably executed by an amateur painter, which helps explain its unique, charmingly childish style. The date 1526 appears at the end of the *emaki.* (Plates 105, 117)

Matsuzaki Tenjin Engi
(Legends of Matsuzaki Tenjin Shrine)

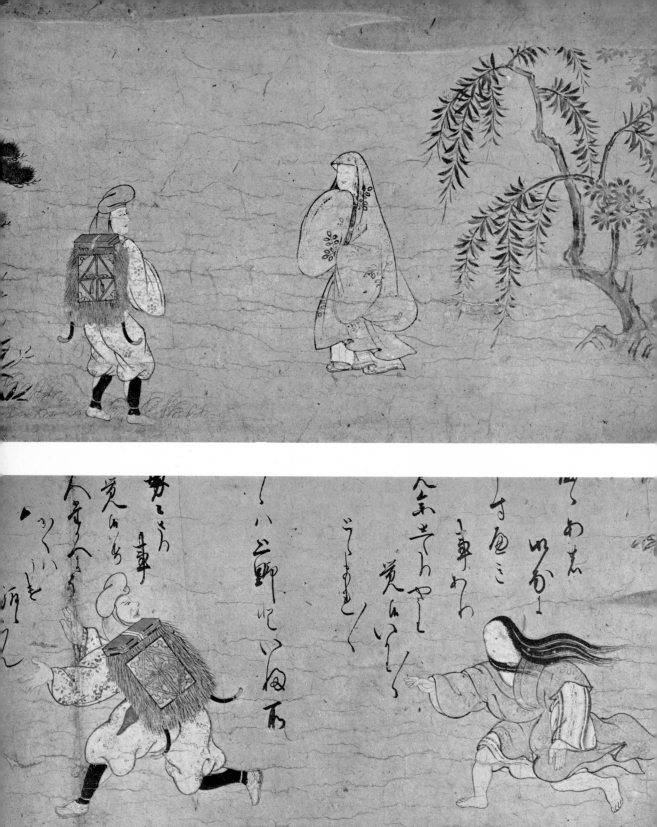

111. Makura no Sōshi Emaki. *Part II. This scroll painting is based on* The Pillow Book, *an entertaining and witty collection of impressions and events of Heian court life written by the observant court lady, Sei Shōnagon, in the early eleventh century. The scene shown here illustrates an episode that reveals Shōnagon's great learning. One May evening, some courtiers passed by the chambers of the empress. When the ladies inside wondered who they were, one man thrust a branch of bamboo into the room, suggesting a double meaning for "this gentleman," an obscure term for bamboo derived from Chinese literature. Opening the sliding door, Sei Shōnagon (shown in the center foreground) found the bamboo and said immediately, impressing everyone, "It was this gentleman." The lady in the inner room at the upper right is the imperial consort. Among the various features typical of the courtly tradition in emaki art shown in this monochrome (hakubyō) scroll painting is* hikime-kagihana, *the stylized convention used to portray the facial features of aristocrats. The nobility were trained to conceal their emotions behind impassive faces, and the ability to do this was considered a mark of good breeding. Respecting this ideal, artists seldom took liberties in their depictions of members of the upper classes. Kamakura period, 14th century. Asano Collection, Tokyo.*

◁ *109–110.* Dōjō-ji Engi. *Muromachi period, 16th century. Dōjō-ji, Wakayama Prefecture.*

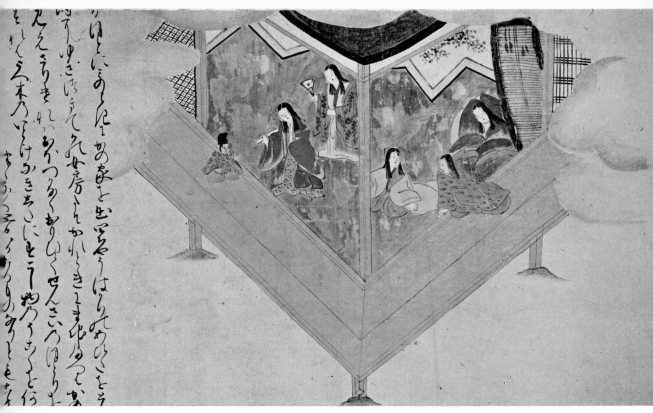

112. Ko-otoko Zōshi (Tale of a Tiny Man). Folk tale. Muromachi period, 16th century. Tenri Library, Nara Prefecture.

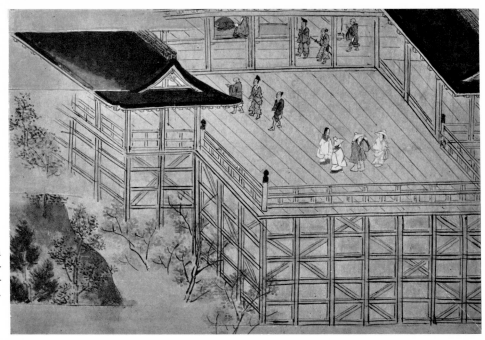

113. Kiyomizu-dera Engi. Muromachi period, 16th century. Tokyo National Museum.

Glossary

Amida Buddha (Sanskrit Amitābha): "Lord of Boundless Light"; the most widely venerated of the transhistorical Buddhas, who presides over the Western Paradise where he receives the faithful after death

ashide-e: "reed-hand painting"; technique by which loose, flowing calligraphy from a poem is used to form part of a pictorial image

Bodhisattva: an inherently enlightened being within the hierarchy of Buddhism who postpones his own complete emancipation from the world until he can save all sentient beings

Buddha: fully awakened or enlightened being. "The" Buddha refers to the Indian sage Siddhārtha Gautama (c. 563–483 B.C.), born the son of the ruler of the Sākya kingdom and also known as Sākyamuni—"the sage of the Sākya clan." According to tradition, Gautama forsook the luxury of his princely existence to seek after Truth. He experienced perfect enlightenment after seven years of religious practices and taught for forty-five years more. As Buddhism developed, it came to include various other "transhistorical" Buddhas, such as Amida, who have no historical basis.

Buddhism: religion inspired by Gautama Buddha, which teaches release from the painful cycle of birth and death through elimination of desire and subsequent enlightenment

eden: pictorial biographies of important historical personages, usually priests

edokoro: official bureau of painting set up by the imperial court and later, the shoguns; also, a temple bureau of painting

ekotoba: "picture and word"; usually refers to scroll paintings in which text and illustration alternate

emaki: illustrated horizontal handscroll, usually of narrative content. Extant *emaki* in Japan date primarily from the twelfth century onward.

emakimono: see *emaki*

engi: in Buddhist doctrine, "dependent origination," a reference to the doctrine that everything results from determinable causes and circumstances, according to the doctrine of karma or "cause and effect." In *emaki,* it refers to the usually legendary origin of a shrine or temple.

fukinuki-yatai: "blown-away roofs"; a device by which roofs and ceilings of houses and rooms are arbitrarily removed in order to show interior scenes directly; probably developed in Japanese art in the mid-eleventh century

gaki: ghosts who are doomed to hunger and thirst

that can never be satisfied because they were avaricious as human beings or because their descendants have not provided them with proper nourishment and care at the household altars

genre painting: painting of scenes of daily life and various customs

hakubyō: "white pictures"; works created in black monochrome ink

hampuku-byōsha: "repetition picture"; technique by which a character is shown again and again in front of a changing background

hikime-kagihana: "slit eyes and hooked noses"; convention used to portray the faces of aristocrats using simple horizontal strokes for eyes and stylized hooks for noses

iji-dōzu: "different time, same illustration"; device used to show multiple actions of a figure in front of a static background

kakemono: vertical, hanging scroll

kana: phonetic syllabary derived from Chinese characters that enabled the Japanese to write their own native language; developed from the ninth century onward

kara-e: "Chinese painting"; Chinese-style painting, often done in monochrome ink, dealing with Chinese themes

kasen: "sages of poetry"; celebrated traditional poets who were honored in *emaki* with portraits and samples of their poems

machi-eshi: "town painters"; painters accessible to the general public and not limited to the service of courts or temples

mandala (Sanskrit *maṇḍala*): a diagrammatic representation of the relationships among divinities, usually Buddhist but also Shintō; a *mandala* may also depict the abode of such deities both in paradise and in sanctuaries on earth

mono no aware: an aesthetic perception and feeling induced by the association of beauty and sorrow

monogatari: a narrative account, such as a novel, story, or history in literary form

nikki: diary

nise-e: "likeness pictures"; type of realistic portraiture developed in Japan from the mid-twelfth century onward

onna-e: "women's pictures"; term used to designate illustrations of such works of court inspiration as romances and diaries; usually show quiet, static, indoor scenes; characterized by the use of the *hikime-kagihana* technique *(see)*

otogi zōshi: short folk tales, sometimes similar to fairy stories, often containing moral precepts; especially popular during the Muromachi period

otoko-e: "men's pictures"; quick, lively sketches full of action and vigor; usually refers to illustrations of fast-moving narratives

Pure Land Buddhism: a popular movement of Buddhism from the late Heian and Kamakura periods on that preached salvation for the faithful in the Western Paradise (Jōdo) of the transhistorical Amida Buddha

roku-dō: the six realms of rebirth—that of heavenly beings *(ten),* human beings *(jin),* angry demons *(ashura),* beasts *(chikushō),* hungry ghosts *(gaki),* and hell *(jigoku).* According to Buddhist doctrine, a living being is doomed to the wheel of birth and death and to rebirth in one of the six realms until he achieves enlightenment and release from the bondage of life.

sarugaku: "monkey music"; humorous and often vulgar dance and song arrangements accompanied by drums and flute, popular during the late Heian and early Kamakura periods

shasenbyō: "oblique line depictions"; pictures, usually of courtly inspiration, characterized by parallel slanting lines to depict architectural elements

shikishi: sheets of paper backed with cardboard, usually about twenty-five centimeters square, used for writing poems or for painting

Shingon: one of the esoteric sects of Buddhism characterized by mystic ritualism and complicated speculative doctrines

Shintō: indigenous animistic religion of Japan; emphasis upon the worship of nature and of ancestors

shogun: military dictator and chief of government under Japan's feudal system (from Kamakura through Edo periods)

sōshi (*zōshi* in compounds): album or sketch of usually short accounts connected to one another by a common theme

sutra: sacred Buddhist scripture

Tendai: an eclectic sect of Buddhism, characterized by esoterism and speculative doctrines

tsukuri-e: "made-up picture"; technique typical of some *yamato-e emaki* in which heavy, opaque pigments are carefully and systematically applied or built up over a white lead pigment base. The original ink outlines, concealed by paint, are repainted over the colors.

ukiyo-e: "pictures of the floating word"; type of art (especially known to the West through its woodblock prints), popular in the Edo period, depicting the amusements and pleasures of the nonaristocratic classes

uta-awase: poetry contest in which two sides submit poems to be judged; competitions of this sort were sometimes the subject of *emaki* art

waka: thirty-one-syllable poem of great lyric content; also called *tanka*

yamato-e: Japanese-style painting, often done in color, depicting Japanese scenes and concerns

zōshi: see *sōshi*

Bibliography

General

Conze, Edward: *Buddhism: Its Essence and Development*. New York: Harper and Row, 1959.

de Bary, Wm. Theodore (ed.): *Sources of the Japanese Tradition*. New York: Columbia University Press, 1958.

Morris, Ivan: *The World of the Shining Prince: Court Life in Ancient Japan*. New York: Knopf, 1964.

Sansom, G. B.: *A History of Japan,* 3 vols. London: Cresset Press, 1958–63.

————: *Japan: A Short Cultural History:* rev. ed. New York: Appleton-Century-Crofts, 1943.

Varley, H. Paul: *The Onin War*. New York: Columbia University Press, 1967.

Literature

Harris, H. Jay: *The Tales of Ise*. Tokyo: Tuttle, 1972.

McCullough, Helen Craig: *The Taiheiki: A Chronicle of Medieval Japan*. New York: Columbia University Press, 1959.

————: *Tales of Ise: Lyrical Episodes from Tenth-century Japan*. Stanford, Calif.: Stanford University Press, 1968.

Morris, Ivan: *The Pillow Book of Sei Shōnagon,* 2 vols. New York: Columbia University Press, 1967.

Waley, Arthur: *The Tale of Genji*. New York: Random House/The Modern Library, 1960.

Emaki

Akiyama, Terukazu: *Japanese Painting*. Switzerland: Skira, 1961.

Fontein, Jan: "Kibi's Adventures in China: Facts, Fiction, and Their Meaning." *Boston Museum Bulletin,* No. 344, 1968.

Morris, Ivan: *The Tale of Genji Scroll*. Tokyo: Kodansha International, 1971.

Okudaira, Hideo: *Emaki: Japanese Picture Scrolls*. Tokyo: Tuttle, 1962.

Paine, Robert T.: "The Scroll of Kibi's Adventures in China: A Japanese Painting of the Late Twelfth Century, Attributed to Mitsunaga." *Boston Museum Bulletin,* No. 183, 1933.

————: *Ten Japanese Paintings in the Museum of Fine Arts, Boston*. New York: Japan Society, 1939.

Seckel, Dietrich: *Emakimono*. New York: Pantheon, 1959.

Soper, Alexander C.: "The Illustrated Method of the Tokugawa Genji Pictures." *Art Bulletin,* Vol. 37, No. 1, 1955.

————: "The Rise of Yamato-e." *Art Bulletin,* Vol. 24, No. 4, 1942.

Tanaka, Ichimatsu (ed.): *Nihon Emakimono Zenshū,* 24 vols. Tokyo: Kadokawa Shoten, 1958–69. Contents: *Genji Monogatari Emaki* (ed. Mori); *Shigi-san Engi* (ed. Okudaira); *Chōjū Giga* (ed. Miya); *Ban Dainagon Ekotoba* (ed. Tanaka); *Kokawa-dera Engi E, Kibi Daijin Nittō E* (ed. Umezu); *Jigoku Zōshi, Gaki Zōshi, Yamai Zōshi* (ed. Ienaga); *Kegon Engi* (ed. Kameda); *Kitano Tenjin Engi* (ed. Minamoto); *Heiji Monogatari Emaki, Mōko Shūrai Ekotoba* (ed. Miya); *Ippen Hijiri E* (ed. Miya); *Saigyō Monogatari Emaki, Taima Mandara Engi* (ed. Shirahata); *Murasaki Shikibu Nikki Emaki, Makura no Sōshi E-maki* (ed. Mori); *Hōnen Shōnin Eden* (ed. Tsukamoto); *Genjō Sanzō E* [*Hossō-shū Hiji Ekotoba*] (ed. Minamoto); *Kasuga Gongen Reigen Ki E* (ed. Noma); *E Inga-kyō* (ed. Kameda); *Nezame Monogatari Emaki, Komakurabe Gyōkō Emaki, Ono no Yukimi Gokō Emaki, Ise Monogatari Emaki, Nayotake Monogatari Emaki, Hazuki Monogatari Emaki, Toyo no Akari Ezōshi* (ed. Shirahata); *Obusuma Saburō E-maki, Haseo Zōshi, Eshi no Sōshi, Jūnirui Kassen E-maki, Fukutomi Zōshi, Dōjō-ji Engi Emaki* (ed. Umezu); *Sanjūrokkasen E* (ed. Mori); *Zenshin Shōnin E, Boki E* (ed. Miyazaki); *Tōsei Den Emaki* (ed. Kameda); *Ishiyama-dera Engi E* (ed. Umezu); *Yugyō Shōnin Engi E* (ed. Miya); *Nenjū Gyōji Emaki* (ed. Fukuyama).

Toda, Kenji: *Japanese Scroll Painting.* Chicago, University of Chicago Press, 1935.

Tomita, Kōjiro: "The Burning of the Sanjō Palace: A Japanese Scroll Painting of the Thirteenth Century." *Boston Museum Bulletin,* No. 139, 1925.

Yashiro, Yukio: "Scroll Paintings of the Far East." *Transactions and Proceedings of the Japan Society,* Vol. 33, 1935.

Index